ICELAND

A Visual Tour

TONY SWEET

Amherst Media, Inc. ■ Buffalo, NY

Dedication

To Emil and Mary Sweet, who taught me to appreciate the awesome beauty of nature and the ethic of hard work.

Published by:
Amherst Media, Inc.
PO Box 538
Buffalo, NY 14213
www.AmherstMedia.com

Publisher: Craig Alesse
Associate Publisher: Katie Kiss
Senior Editor/Production Manager: Michelle Perkins
Editors: Barbara A. Lynch-Johnt, Beth Alesse
Acquisitions Editor: Harvey Goldstein
Editorial Assistance from: Carey A. Miller, Roy Bakos, Jen Sexton-Riley, Rebecca Rudell
Business Manager: Sarah Loder
Marketing Associate: Tonya Flickinger

ISBN-13: 978-1-68203-390-6
Library of Congress Control Number: 2018953355
Printed in the United States of America
10 9 8 7 6 5 4 3 2 1

AUTHOR A BOOK WITH AMHERST MEDIA

Are you an accomplished photographer with devoted fans? Consider authoring a book with us and share your quality images and wisdom with your fans. It's a great way to build your business and brand through a high-quality, full-color printed book sold worldwide. Our experienced team makes it easy and rewarding for each book sold—no cost to you. E-mail **submissions@amherstmedia.com** *today.*

www.facebook.com/AmherstMediaInc
www.youtube.com/AmherstMedia
www.twitter.com/AmherstMedia
www.instagram.com/amherstmediaphotobooks

CONTENTS

ABOUT THE AUTHOR

Tony Sweet is a Nikon Legend Behind the Lens. After successful careers as a jazz musician/ educator, and professional magician, Tony settled on photography as his chosen means for personal expression. Beginning as a film photographer, Tony became facile in image-editing software and plug-ins and is an in-demand speaker on creativity in the digital age throughout the United States and Canada.

Tony and Susan Milestone conduct Visual Artistry photography location workshops throughout the United States, Canada, Cuba, and Iceland. Tony maintains an active speaking schedule to professional and amateur photography organizations, and industry trade shows. He also conducts Visual Artistry seminars.

Tony's photography is published worldwide in every medium. His work is represented by Getty Images, and his photographs are used by Nikon, Singh Ray, Alien Skin Software, Topaz, Lensbaby, and others for national ad campaigns.

An interview with Tony on macro photography was published in *The New York Times.* He has authored five books on the art of photography and, with Master Photo Workshops, has co-produced four photography DVDs, as well as an iPhone instructional video series.

The first book in his Fine Art Nature Photography e-book series, *Creative Techniques and the Art of Self Expression,* was just released.

Praise for This Book

"For decades, Tony Sweet's lyrical photographs have immersed audiences across the globe in the beauty of the world. From the abstract renditions of patterns in the sand to infrared interpretations majestic mountainous views, his diversity of perspectives sheds new light on natural and manmade subjects. In his latest presentation of visual poetry, this striking collection of evocative images celebrates—and will surely transport you to—Iceland's intriguing and otherworldly landscape."

—Colleen Miniuk, professional outdoor photographer and author of
Photographing Acadia National Park: The Essential Guide to When, Where, and How,
www.cms-photo.com

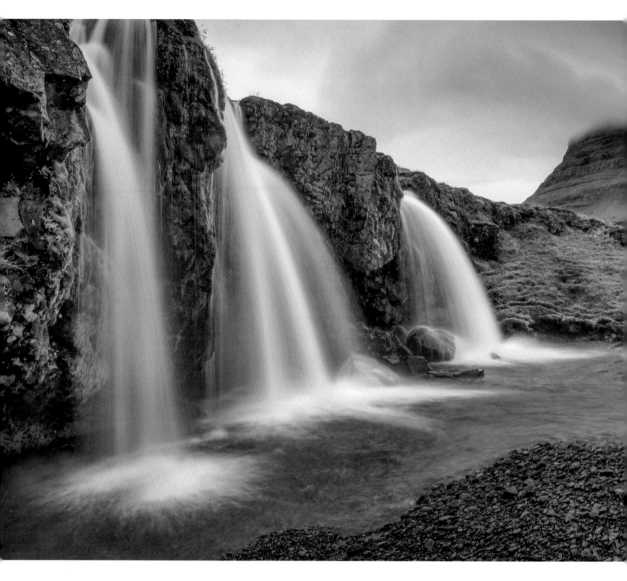

Mt. Kirkjufell

above—Mt. Kirkjufell is one of the most iconic scenes in Iceland. The three small waterfalls are the perfect foreground for the mountain, also known as "The Witch's Hat." Iceland summers are quite wet and green, which comes as a surprise to most people.

This image is referred to as a "stitched panoramic." Several images were made moving the camera from left to right, then "stitched" together in software, creating the long image.

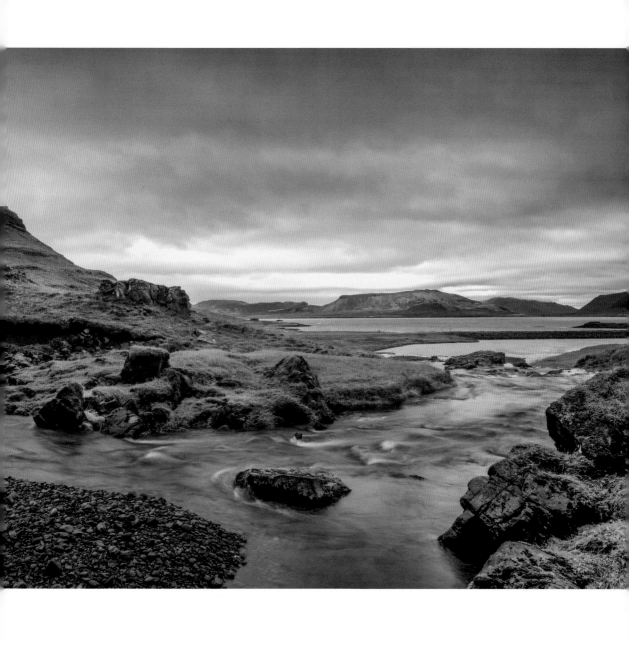

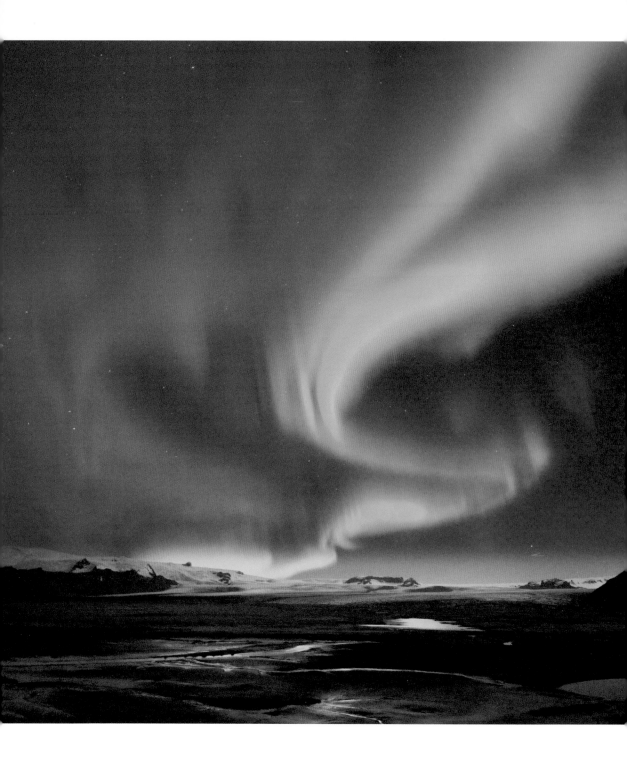

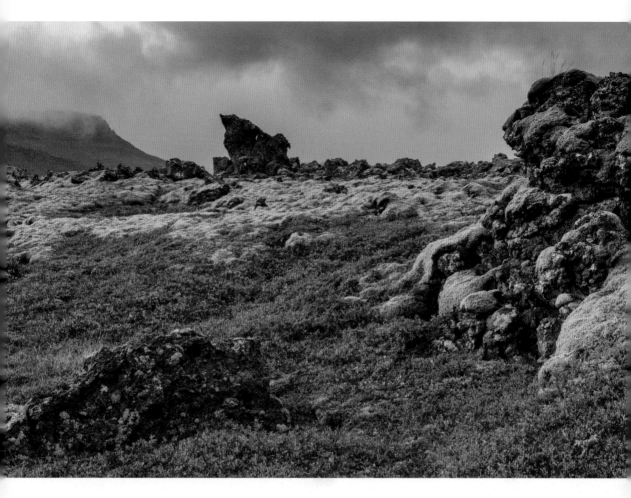

Aurora Over Breidamerkurjokull

previous page—The best time to view the aurora borealis is on a cloudless or mostly cloudless night in complete darkness: September through March. To photograph this phenomenon, a tripod and wide-angle lens (f/2.8 or faster) are needed. Because of the brightness of the aurora, the exposures can be surprisingly short, in the range of 6 to 10 seconds. Of course, exposure bracketing is recommended.

Note: The day before photographing the northern lights, pre-focus your widest lens on a distant subject. Use gaffer's tape to keep the focusing ring from moving, as it is very difficult to manually focus at night. Shoot at the widest aperture (f/1.8, f/2, f/4, etc.).

above—Iceland's fall color rivals that of a particularly good fall color display in New England. The red blueberry leaves dot this lava field, with areas of lime-green lichen. Overcast skies are ideal; they spread the light evenly, avoiding very bright highlights and deep shadows, with better color saturation.

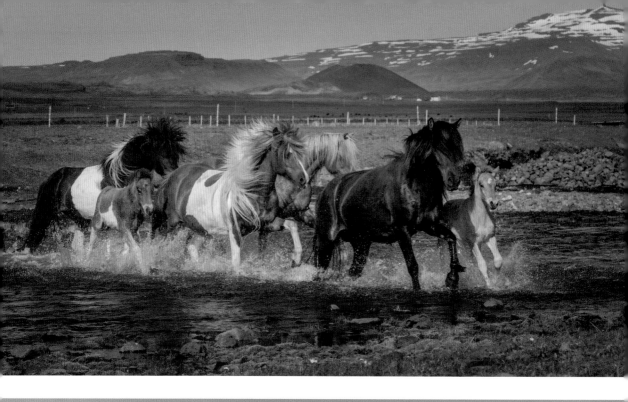
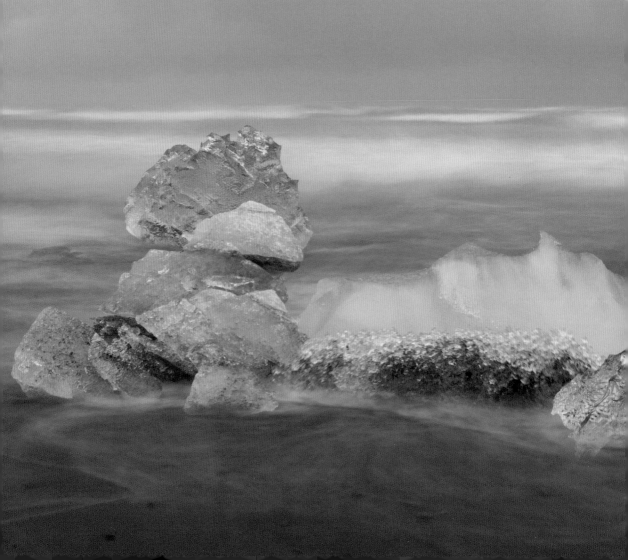

Horses on Mýrar in Snæfellsnes

previous page, top—On Snæfellsnes Peninsula, the Icelandic horses are a favorite subject and can be photographed, in many cases, from the side of the road throughout the year.

For this image, our Iceland guide arranged to have us photograph on a ranch, where the horses were run back and forth through a small stream for our group of photographers.

Ice on the Beach at Jökulsárlón

below—Jökulsárlón is the only area of its kind in Iceland. Ice formations flow from a lagoon into the ocean, then on high tide, will land back on the black-sand beach, referred to as Jewel Beach or Diamond Beach. The original image was cropped to create the panoramic format.

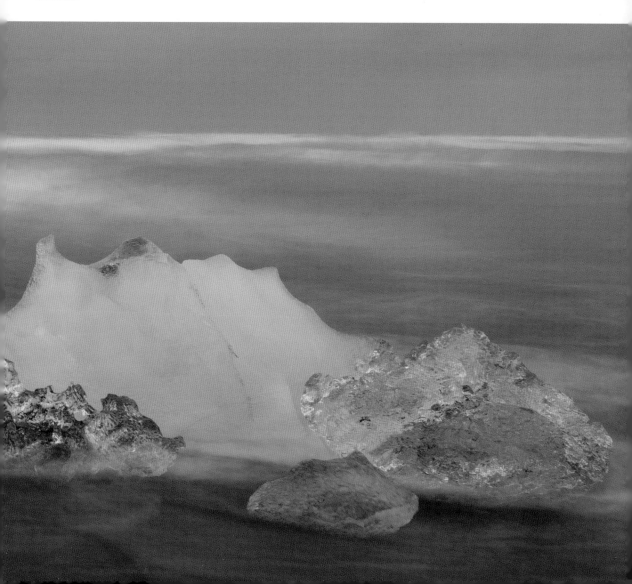

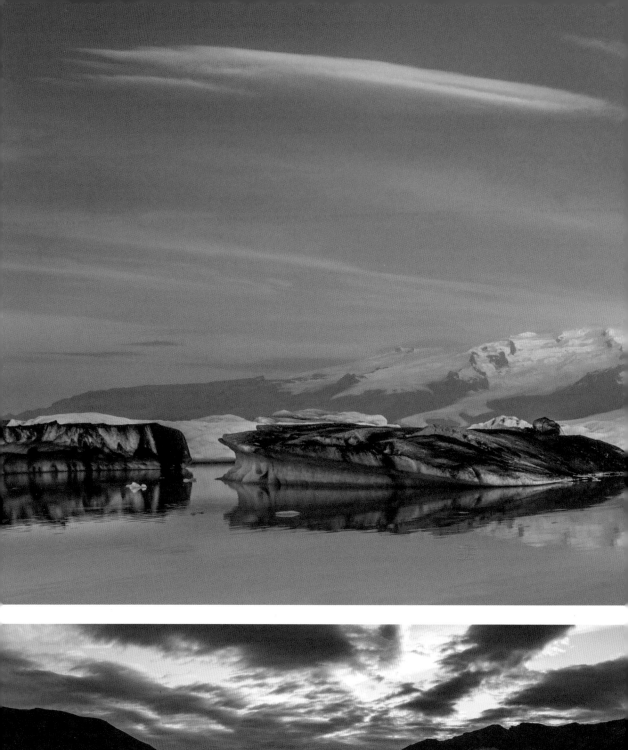
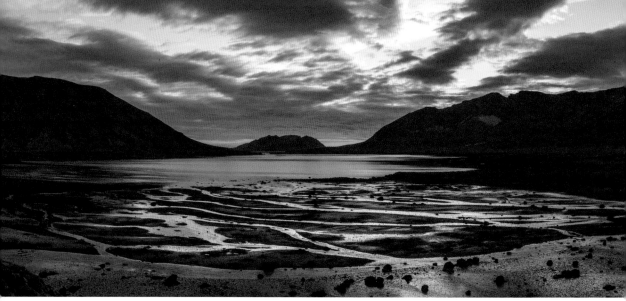

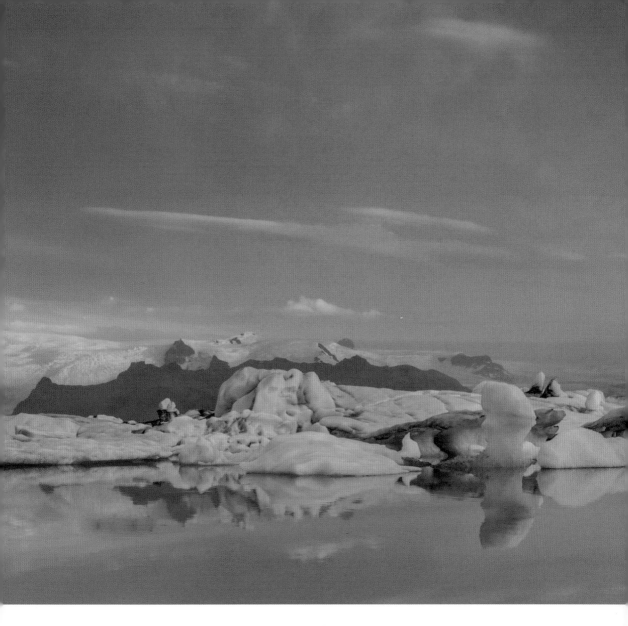

Jökulsárlón Under Vatnajökull

above—Glacial lagoon (Jökulsárlón) at first light. One can feel the quiet in this scene. I have been to this place many times, and every time, the amount of ice is different and the ice blocks are constantly changing. It's important to realize that there are no guarantees at these locations. The amount of ice in the lagoon and on Jewel Beach can range from dense to sparse to none.

Hraunsfjördur at Snæfellsnes

previous page, bottom—The low sun illuminated the clouds, reflecting the color onto the low-tide foreground alternating wet/dry patterns. This created a strong foreground visual anchor and a sense of depth.

This photograph is a stitched panoramic made with seven images.

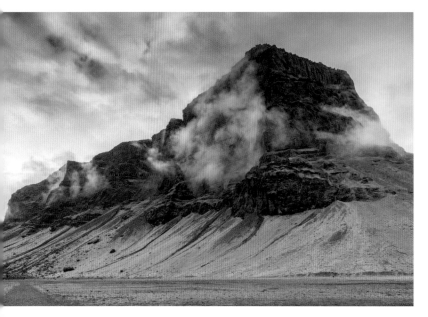

Lómaknúpur at Sida

Like all mountains, Lómaknúpur creates its own weather and can be rendered in many different ways.

top—I used a slight wide-angle lens to fill the frame with the subject from a relatively close distance.

bottom—Switching to a telephoto lens, I was able to get a tighter, more moody view.

following page, top—To create this image, I walked to the extreme right side of the subject and, with a telephoto lens, zoomed in to isolate an interesting pattern.

following page, bottom—When we got to our hotel, I looked back to see a swirling mist around the subject.

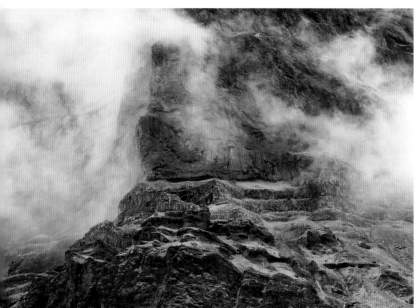

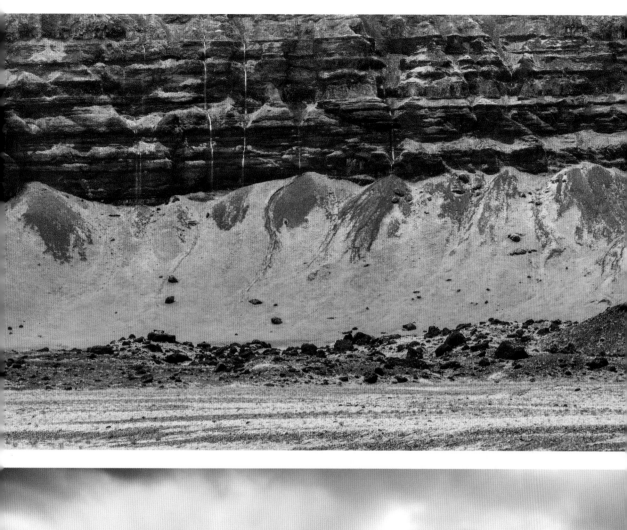
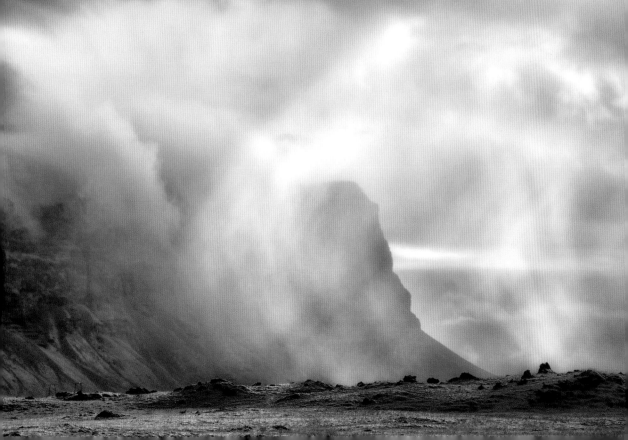

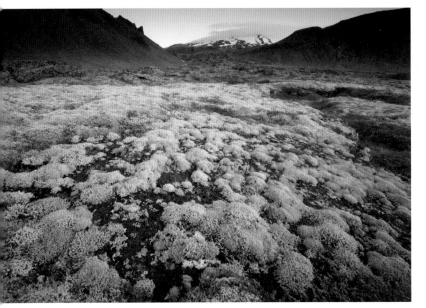

Lava by Arnarstapi at Snæfellsnes

top—The attraction of this scene of was the wide-open field of lichen and lava juxtaposed with the distant snow-covered volcano (Snæfellsjökull) at first light. I used a wide-angle lens and a very low camera angle to create a sense of depth.

center—This image is from the same area as the image above, but photographed a little later in the day and farther to the right.

It's always a good idea to take more than one picture. Walk around to find different compositions, and return at different times of the day—and ideally at different times of the year—in various weather conditions.

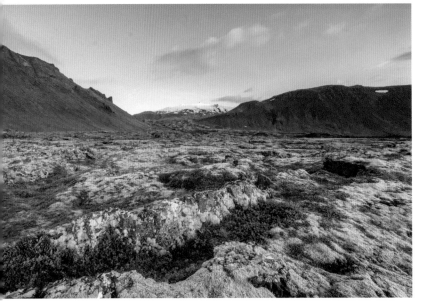

Eldhraun

bottom—Lava fields are fun to view, but it can be deceptively difficult to make interesting photos. The hill with a single rock at the top is unusual, and with the blue sky and soft clouds, made for a clean and colorful composition.

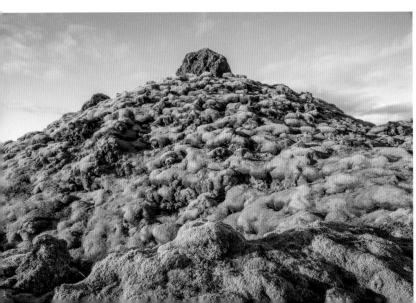

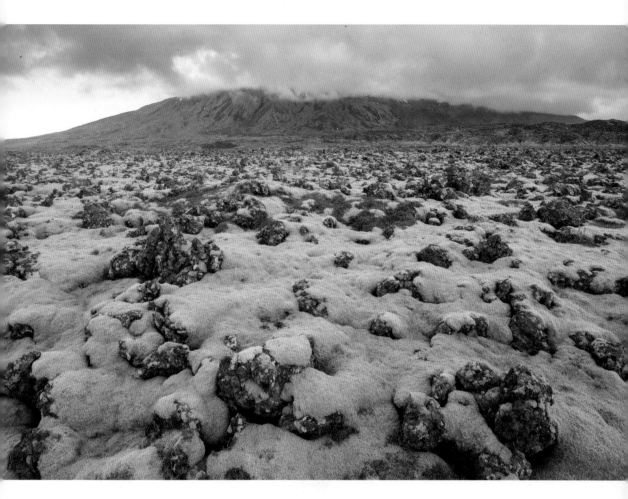

Under Snæfellsnes Glacier

above—Driving along the south coast is a beautiful trip. There are miles upon miles of lava fields. Much of the lava, appearing as vast, moss-covered areas, are the result of the 1783 Lakagígar eruption, which is thought to be the largest quantity of lava from a single eruption in history.

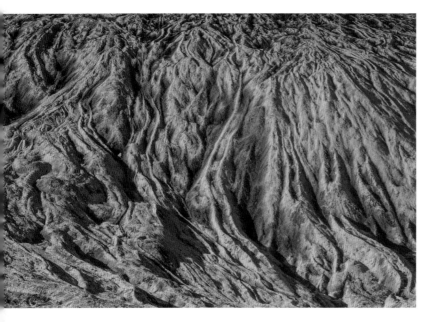

Slope Under Snæfellsnes Glacier

A land of nature's patterns.

top—Glacial rills. The lines and channels are created by melting snow flowing down the glacier.

bottom—Svinafell glacier. This telephoto capture extracted a very small pattern from this glacier. The image was later processed to have the appearance of a pencil sketch.

following page, top—On the Domadals route, glacial rills. Deep cuts in the mountains are the result of melting snow, revealing early spring greens.

following page, bottom—Slope of Hanarfjall, spring hillside. The intense greens appear in summer and create abstract patterns against the dark mountain minerals.

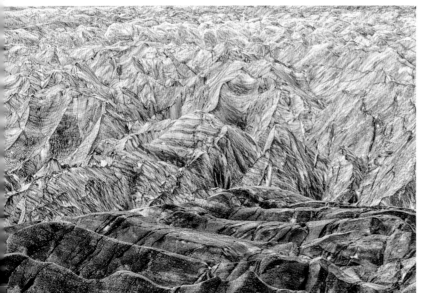

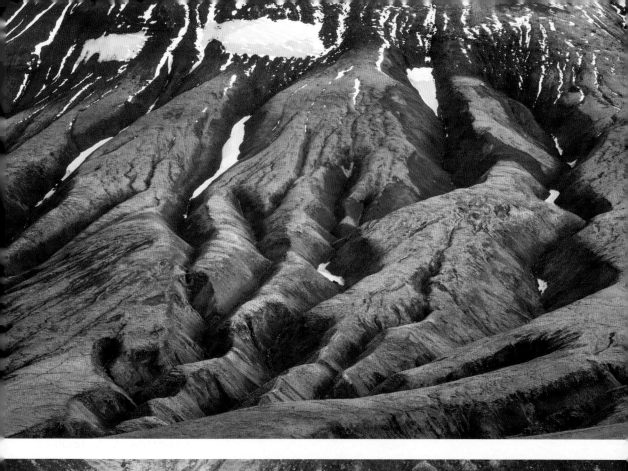
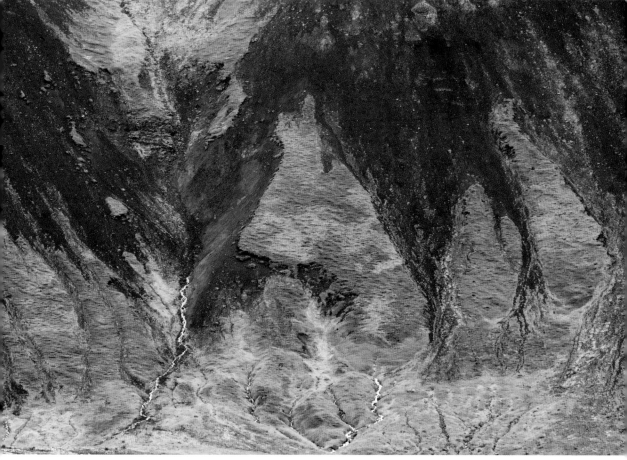

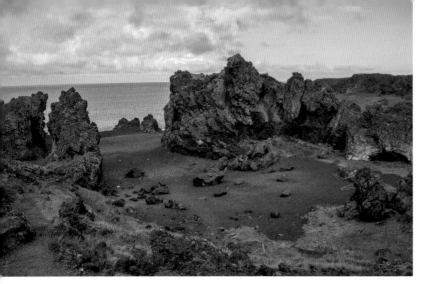

Djúpalónssandur

top—The west coast of Snæfellsnes National Park is black-sand beaches and craggy coastlines. This has a dystopian feel, like one is at the edge of the world. I used a 35mm wide-angle lens and got up as high as I could to shoot downward to maximize the foreground and minimize the sky.

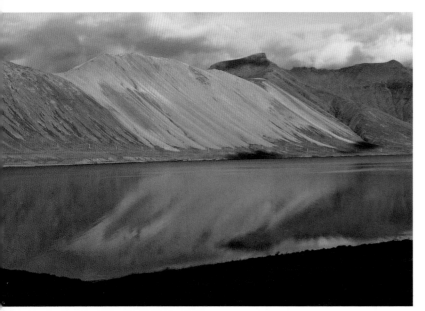

Icelandic Interiors

center—The small lake was still, which is not uncommon early and late in the day. Since the shade was quickly encroaching the bottom of the frame as the sun set, it was important to work quickly. The warm, late-afternoon light created a soft color palette.

bottom—The mountains in the northeast rise up quickly from the water's edge in dramatic fashion, dwarfing the scattered small groups of homes and farms, creating a grand sense of scale. Photographing in low-angle sunlight created the dramatic contrast.

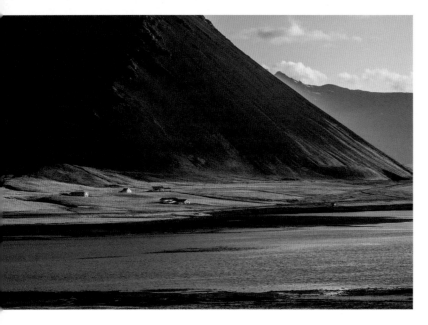

Snæfellsnes National Park

below—This fall scene was photographed on one of many of the great short hike routes in Snæfflesnes and throughout Iceland. Here are some notes on the composition:

1. What may look like a random pointing of the camera was purposefully selected to place a large inverted triangle at the upper left, with the tip of the triangle pointing to where the hikers are walking.
2. There is a long red S-curve, starting at the bottom-left corner and leading to the same place.

Both of these compositional elements lead the viewer through and into the frame.

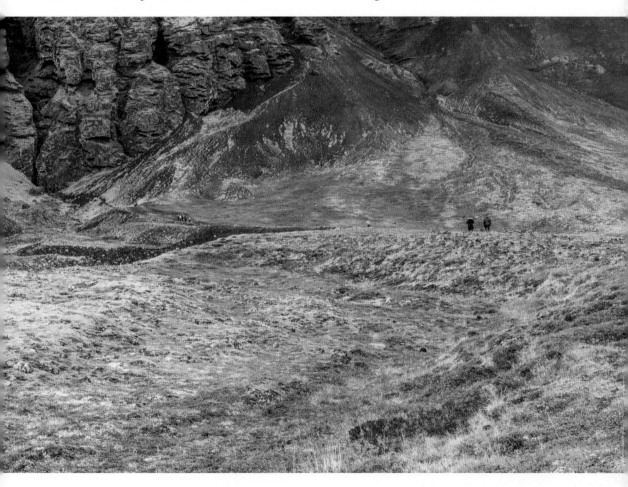

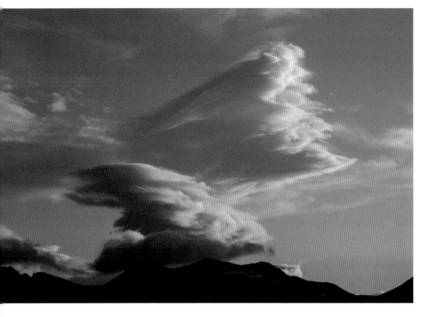

Clouds Over Snæfellsnes Peninsula

top—The winds in Iceland can be daunting—up to 100mph or greater! This image, where the clouds appear to be ripped apart by the winds, was made in a 50mph+ wind on land (much higher wind speeds at cloud level). Raising the ISO to 1000 and lowering the aperture to f/5.6 allowed for the use of a shutter speed of $\frac{1}{250}$ second to avoid wind shake. Still, I waited until the wind momentarily abated to press the shutter.

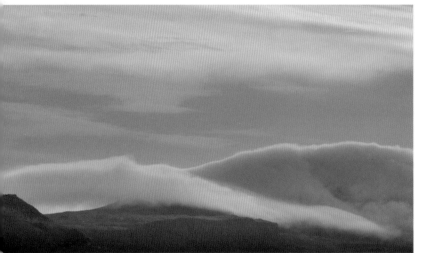

center—This pastel dawn and moving cloud cover create a soft color/graphic image of shape, form, and color. This image was made at Snæfflesnes National Park in July, when it never gets completely dark. The capture was made at 3:00am.

Jökulsárlón by Breidamerkur Glacier

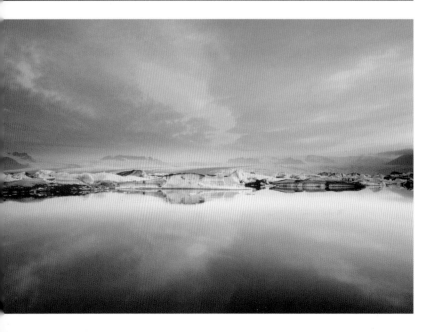

bottom—Iceland is known as the Land of Fire and Ice, but it can also be quite pastel.

This image is from Jökulsárlón. In Iceland, soft light and pastel dawn cloud color can last for 30 minutes or longer, whereas in the States, this quality of light may last a minute or less.

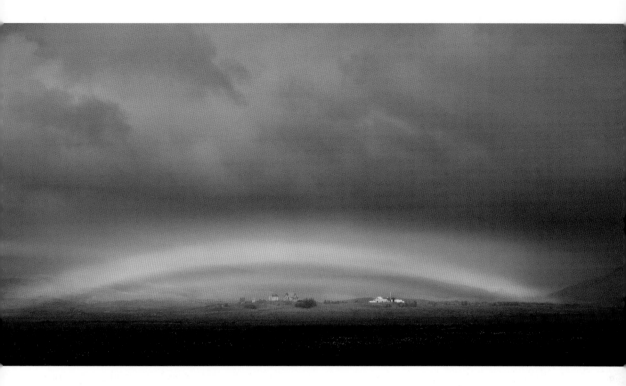

Rainbow Over Farm at Mýrar

above—Rainbows occur frequently in Iceland at the edge of a storm or during low side light with moisture in the air. A small window of sunlight created this rainbow, framing a small Icelandic farming community.

Skógafoss

following page—The photographs on the next three pages are from an iconic south coast waterfall called Skógafoss. After a short climb, one can be at eye level with the falls. We were lucky to have a rainbow, which occurs more than one would expect on this waterfall. The very smooth water was created by mounting the camera on a tripod, with a 10-stop neutral density filter on the lens, allowing for a 2-minute exposure.

top—Normally, Skógafoss is packed with tourists and campers, but at 3:00am, everyone had cleared out, and we had the place to ourselves. This image is impossible to get in a single exposure. This is a three-photo HDR (high dynamic range) image.

bottom—We were able to walk close to the bottom of the falls when the wind changed direction, allowing us to photograph this cool reflection pool and bright rainbow. When the wind shifted back to us, we had a few seconds to cover the gear before getting drenched.

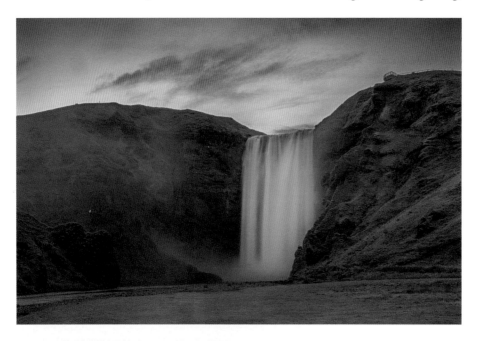

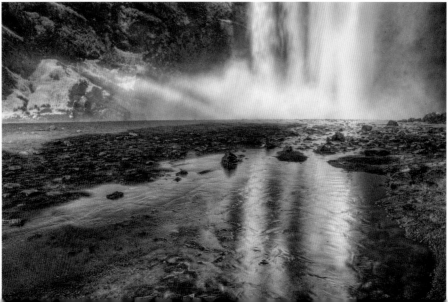

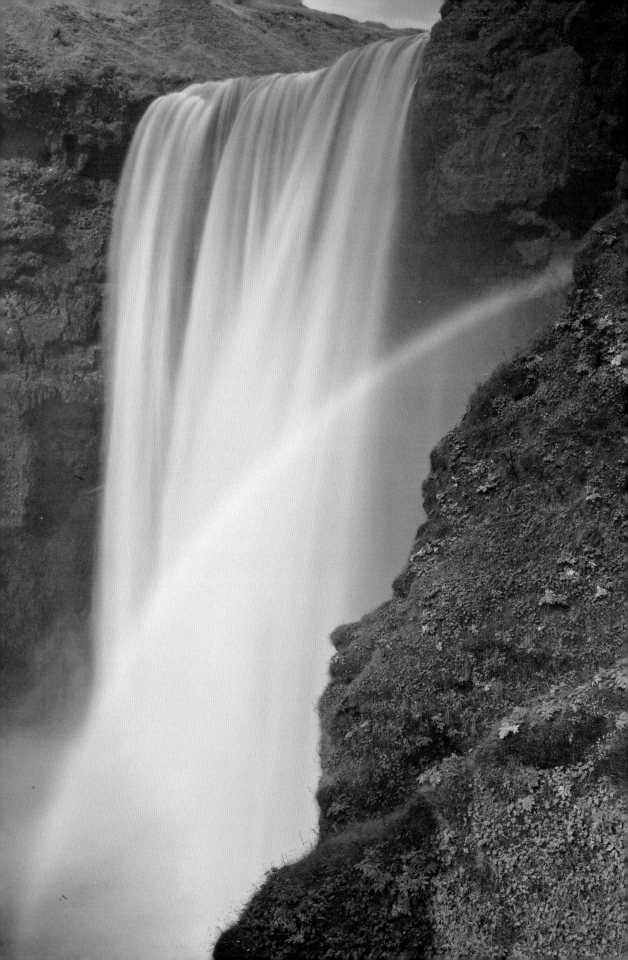

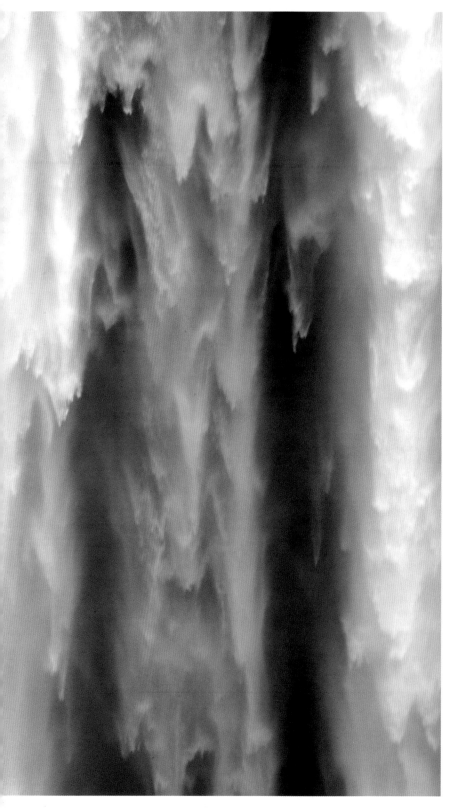

(More) Skógafoss

left—The hypnotic cascades of Skógafoss are fun to photograph at various shutter speeds. A tripod is a good idea so that you can study your composition and the mesmerizing patterns of falling water.

following page—We were lucky on this day to get a rock poser with a particularly striking pose. People often walk up to that area, standing on that rock for photographs of themselves, with the falls as the background.

Choosing a high-contrast black & white look with a center spot (made using the Radial tool in Lightroom) allowed me to produce the image I was seeing in my imagination.

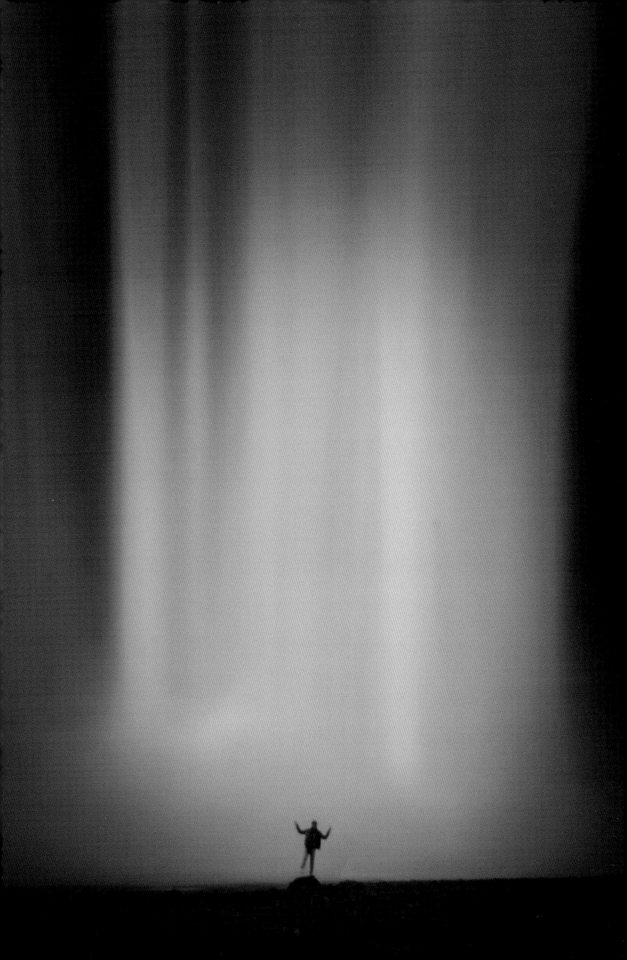

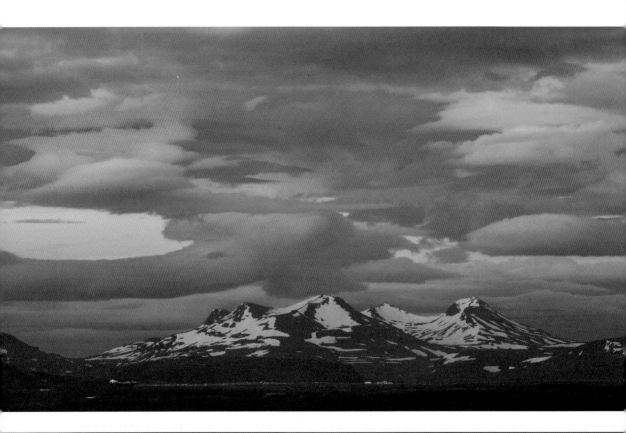

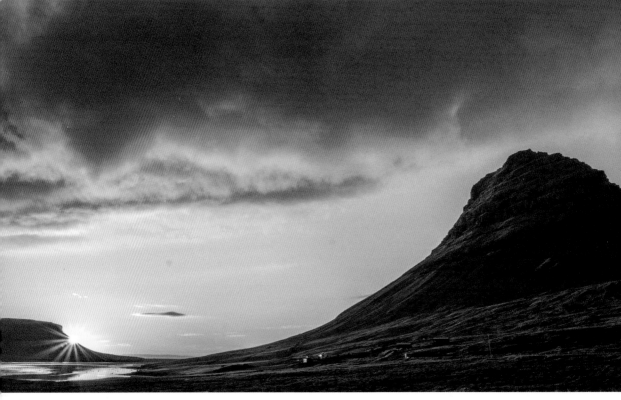

Evening Twilight in Stadarsveit

previous page, top—This pastel scenic, taken on Snæfellsnes Peninsula, with snow-capped peaks and pink clouds, has been on my watch list since going to Iceland. I'm from the east coast of the United States, where this quality of light is quite fleeting. I find myself always rushing to get the light before it fades, which can happen in a matter of seconds. This is not the case in Iceland. At this latitude, the scene maintained the color for over an hour.

Kirkjufell on Snæfellsnes Peninsula

previous page, bottom—Sunset at Mt. Kirkjufell, also known as "The Witch's Hat." I wanted a little different perspective. I moved down the dirt pathway to have the sun partially obstructed behind the hill as it continued to light the clouds with an ever-increasing warm glow. The sun star is the result of using a small aperture, in this case, f/16.

Old Harbor at Flatey Island

below—On this day, we set our alarms for 1:30am, hoping that the thin, high clouds would light up. Flatey Island is idyllic, small, and peppered with little homes, farms, and churches. One can traverse the circumference of the island in 90 minutes.

When first leaving the hotel, the small pond was full. On the way back, enough water had filled in the pond to create a circular reflection pond.

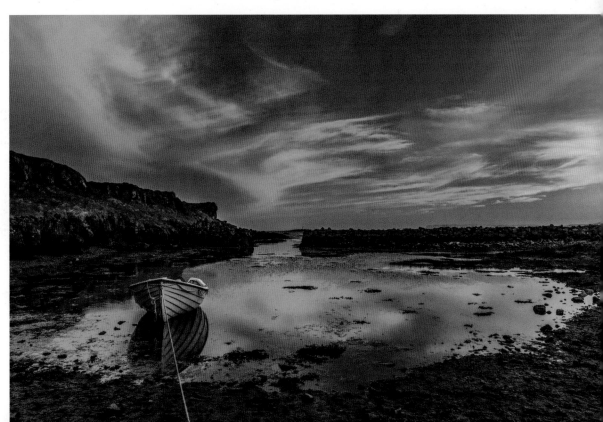

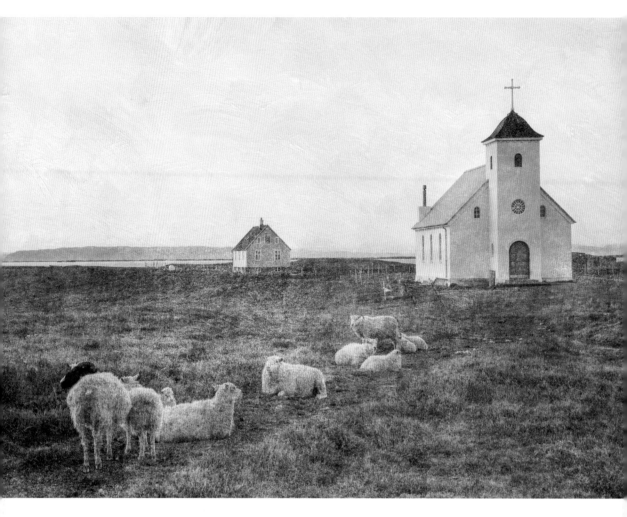

Church on Flatey Island

above—This idyllic scene was captured on a quiet morning. The lambs lined up nicely, but I was waiting for some heads to turn. As the black-headed lamb turned his head to the side, I quickly pressed the shutter before he turned to walk away.

The white sky made an excellent neutral color palette to apply a high-key (bright) texture overlay to the image.

Church on Snæfellsnes Peninsula

below—Dusk lasts a while in the summer. Actually, it never gets completely dark. The late light in this image lasted for hours. The church lights nicely separated it from the dark grounds around it.

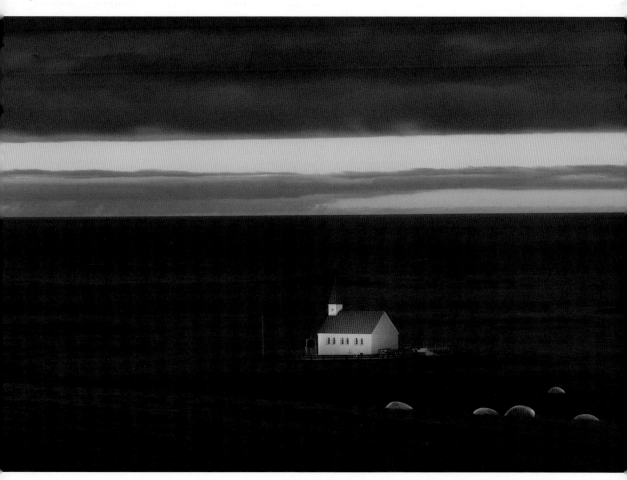

Dagverdará: Abandoned Farm on Snæfellsnes Peninsula

below—Abandoned farms, houses, herring factories, old cars, and miscellaneous structures can be found throughout Iceland. This abandoned house, seemingly in the middle of nowhere, is in northwest Iceland.

Three exposures were blended to create this HDR image.

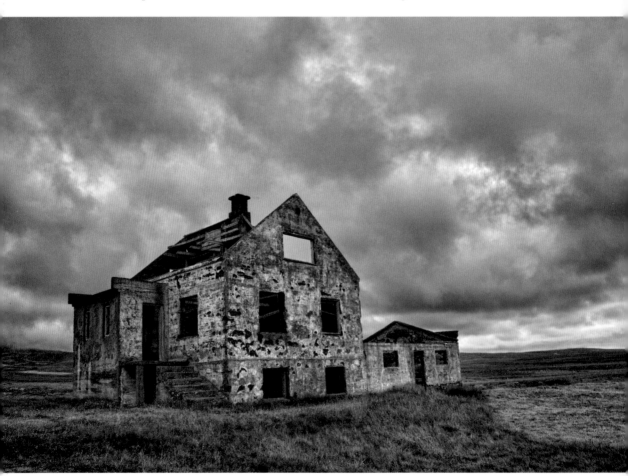

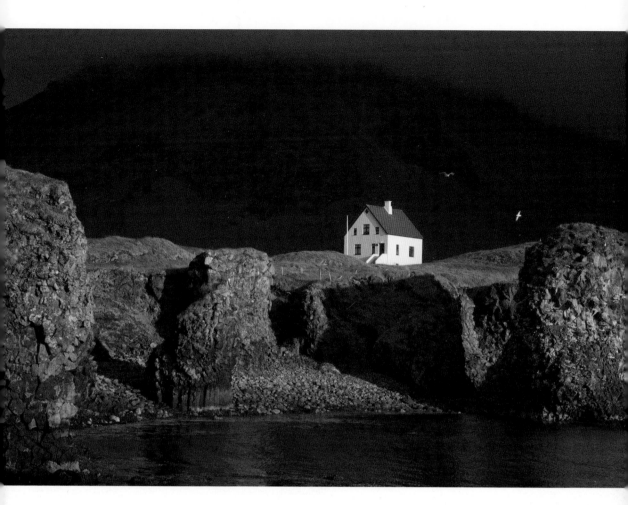

Arnarstapi on Snæfellsnes Peninsula

above—A low-angle sunrise lit the keeper's house nicely, while the background mountain remained in the shade. This is a dramatic way to create separation in a composition.

There were many seagulls flying through the scene. All but two were cloned out to simplify the image.

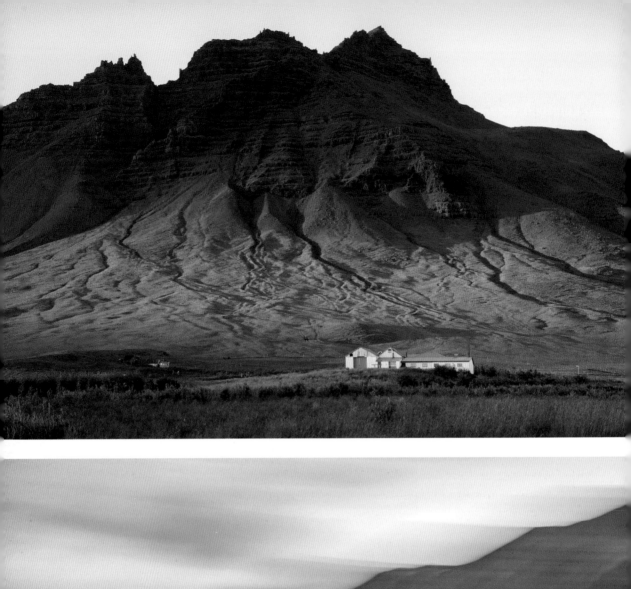
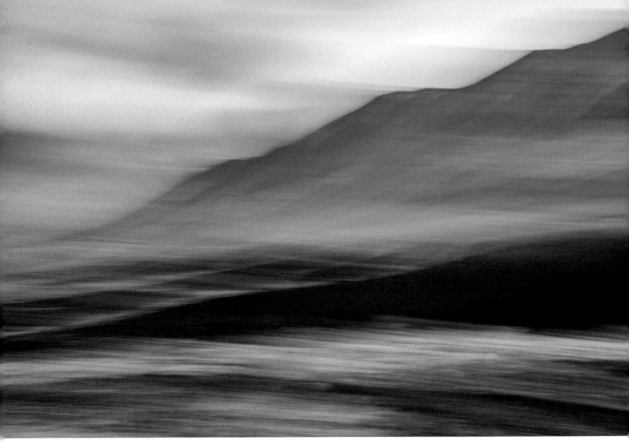

Farm on Southern Snæfellsnes Peninsula

previous page, top—A low-lying sunset peeks under a cloud bank to light up the bottom of the mountain and blue farmhouse on Snæfflesnes Peninsula. Always have a camera in the car and be prepared to stop and photograph on a moment's notice.

Berserkjahraun on Snæfellsnes Peninsula

previous page, bottom—This is what is referred to as a "swipe"—a technique in which the camera is moved during a longer exposure (approximately 1 second) to create a painterly look.

It's good practice to make many images, as every time you move the camera during a long exposure, the image is different.

top and bottom—Both images on this page were made at an enormous lava field in Snæfflesness National Park. Iceland in the fall has the same color palette as an excellent fall color display in New England.

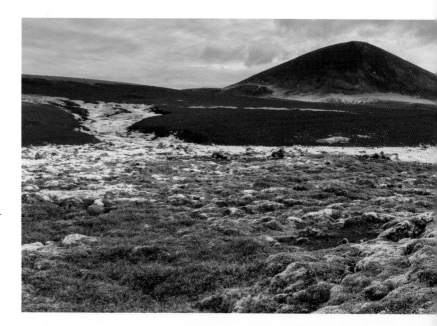

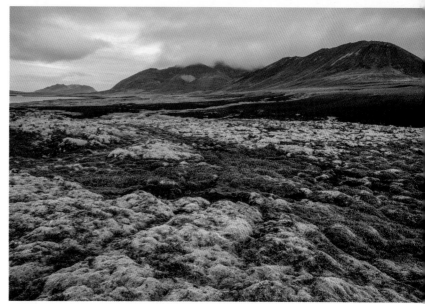

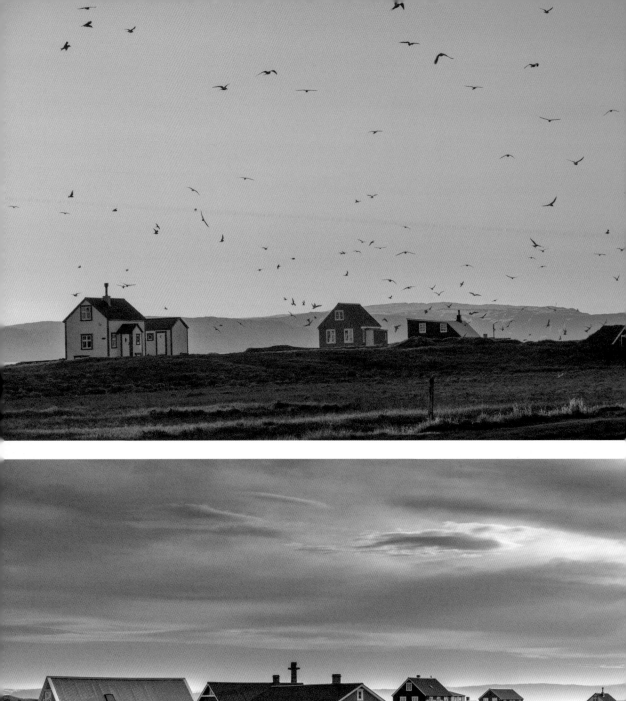
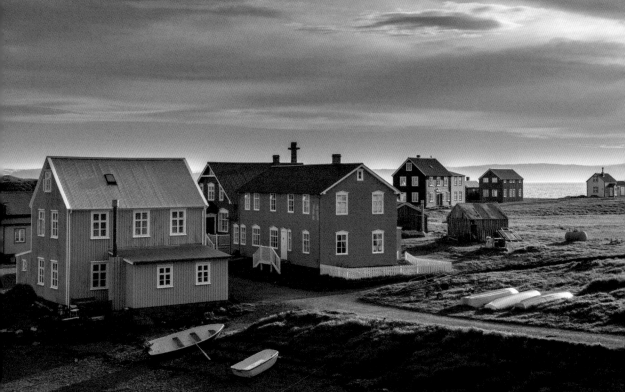

Flatey Island

previous page, top—Flatey Island is a nesting area for arctic terns. They are aggressive in protecting their nests. If one gets a bit too close, the tern will fly low and let out a loud, blood-curdling, adrenaline-activating call. However, on this quiet dawn, the terns took off en masse as the sun touched the island.

previous page, bottom—The city center on Flatey Island at dusk (about 11:00pm) in July. The freshly painted houses are juxtaposed with the cool, metallic-like sky.

top—The church and pastor's house on a small hill on Flatey Island are almost dwarfed by the large, puffy clouds moving in from the west.

Arnarstapi

bottom—Vacation homes in Arnarstapi, on the Snæf-flesnes Peninsula, frame the ever-present church in the background. The use of a wide-angle lens (24mm) created the perspective falloff from the right to the left, adding depth in the scene, as well as leading the eye to the framed church.

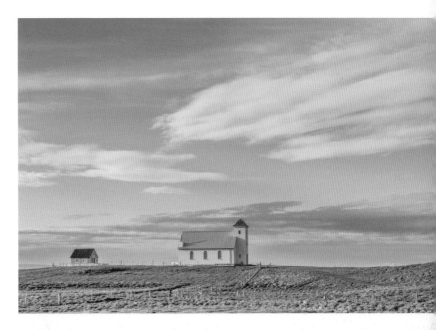

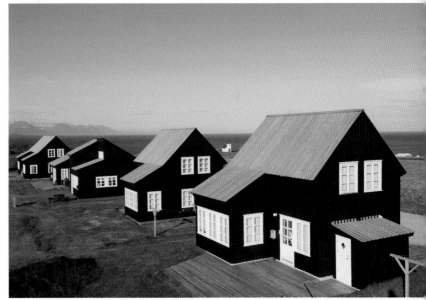

Mt. Kirkjufell

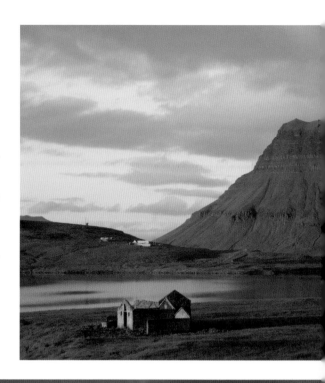

top left—Mt. Kirkjufell is a great sunrise and sunset venue, as the sun rises to the right and sets to the left in the spring and summer.

top right—Here is a side view of Mt. Kirkjufell, facing the sunset sky. Notice how the red lighthouse at the left side of the image is dwarfed by the size of the mountains.

bottom—The mountain, lake, and mirror reflection inspired this panoramic interpretation of Mt. Kirkjufell. To create this photograph, I placed my camera on a tripod with a special panoramic device, then created eleven images that I stitched together in postproduction.

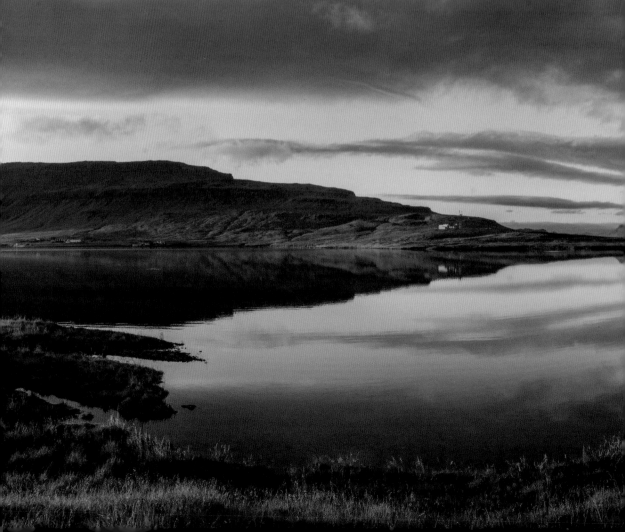

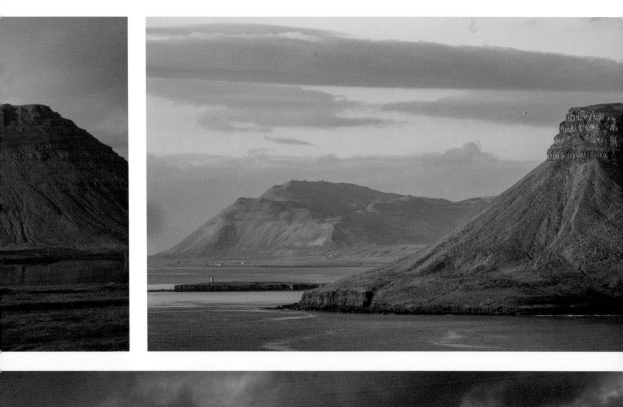

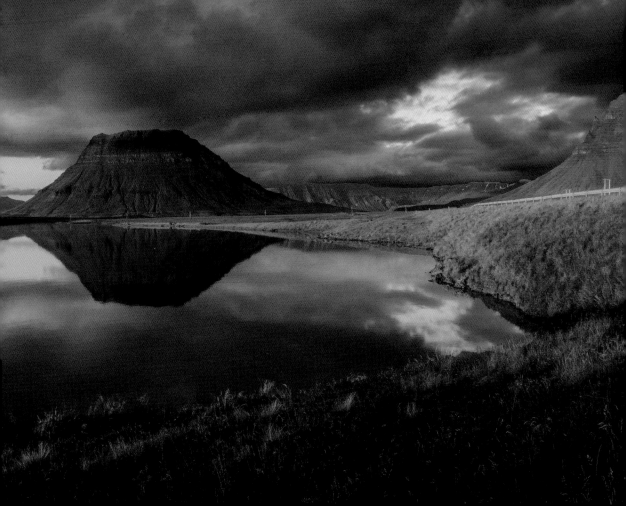

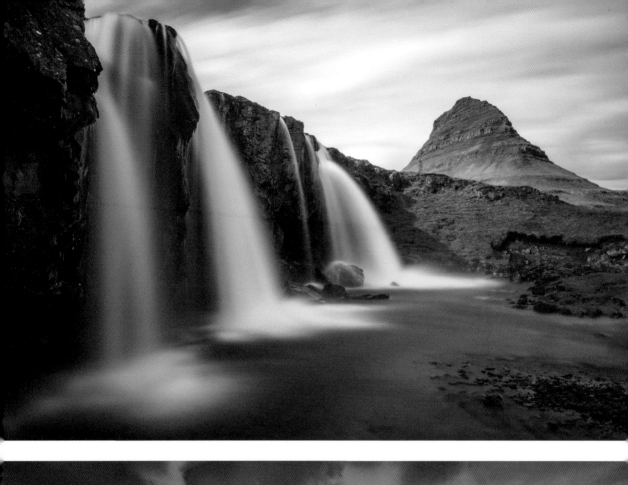
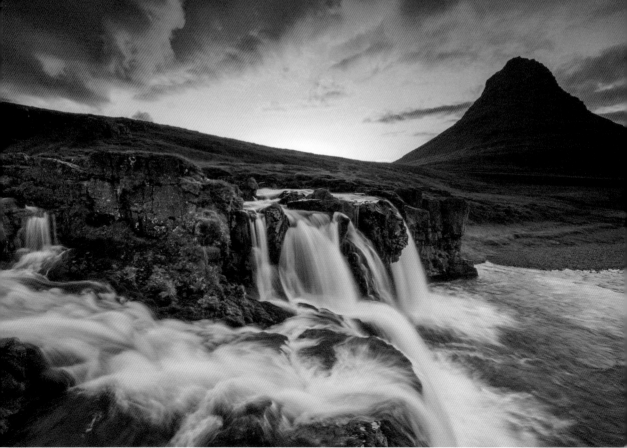

Classic Views of Kirkjufell's Waterfall

previous page, top—This image was made with a 1-minute exposure, which was a bit tricky, as I had to keep an eye on the front lens element for waterdrops from the splashing waterfalls.

previous page, bottom—The high dynamic range of this image meant that getting the sky and foreground to come out in a single image would be impossible. Rather than create an HDR sequence, I decided to take two images: the first with a properly exposed sky, and the second with a properly exposed foreground and waterfalls. I cut and pasted the sky onto the properly exposed foreground image to seamlessly blend the two images.

above—Here, I used a 2-minute exposure to blur the clouds. Next, the image was dramatically darkened. The Radial tool in Lightroom was used to brighten the waterfalls.

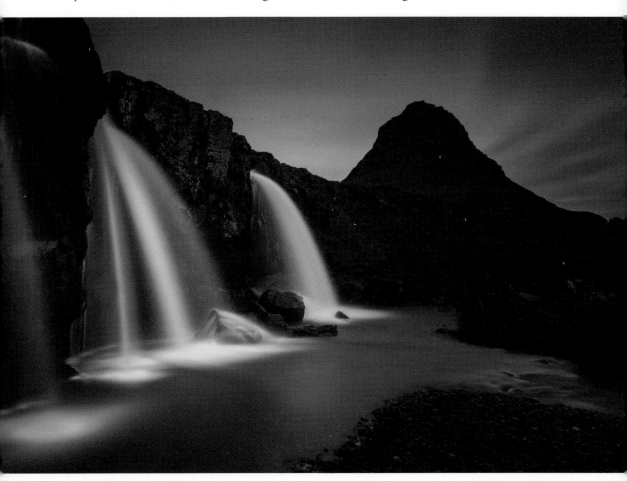

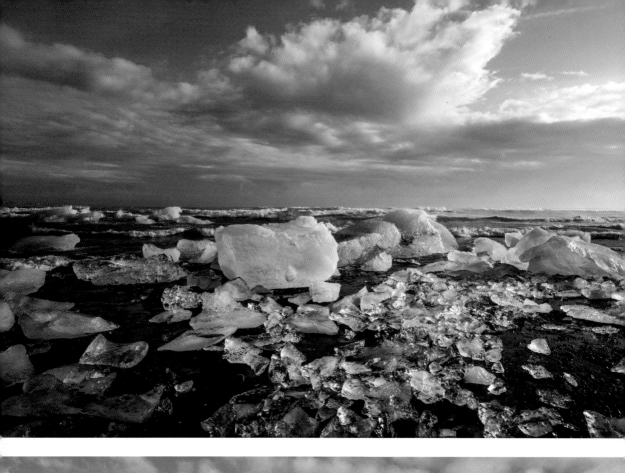
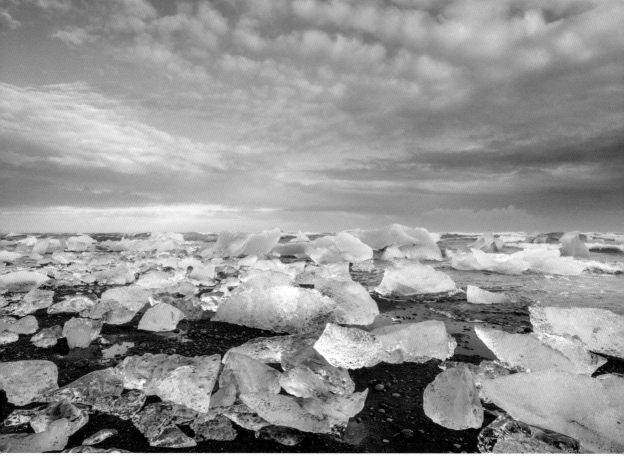

Ice on the Beach at Jökulsárlón

previous page—These images show an area known as Jewel Beach. It is a unique black-sand beach with ice formations that flow out of the glacial lagoon (Jökulsárlón), washing back on shore during a high tide.

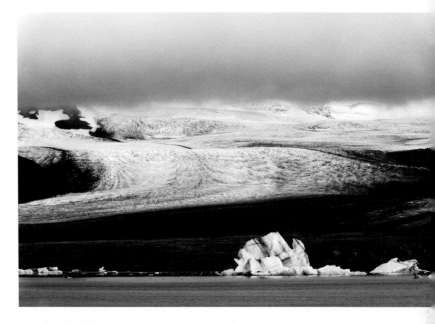

Fjallsárlón

top—The vastness of this glacial lagoon is illustrated by the large iceberg dwarfed by the glacier, fading up and into the low-lying clouds.

Jökulsárlón

bottom—The number of icebergs populating the lagoon can vary dramatically depending on the weather conditions.

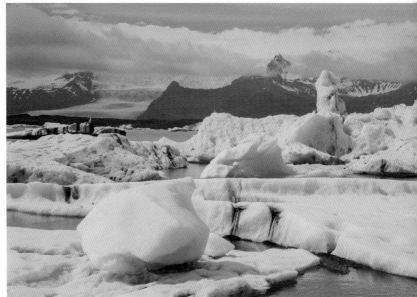

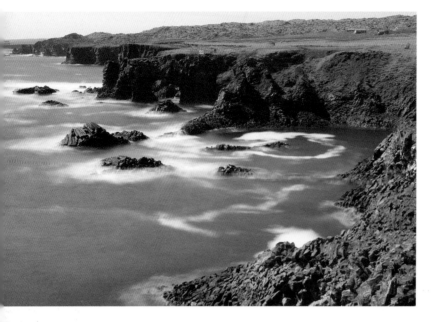

Hellnar Coast on Snæfellsnes Peninsula

top and bottom—These images were made by simply photographing to the right, then turning and photographing to the left.

Note: All of the images on these two pages are from the west coast of Iceland, at Snæefflesnes National Park.

Arnarstapi on Snæfellsnes Peninsula

following page, top—Later in the morning at a keeper's house in Arnarstapi, I created a 4-minute exposure using a 15-stop neutral density filter, which softened the moving clouds and smoothed the water.

following page, bottom— Along a lengthy paved walkway from the keeper's house by the cliffside is my favorite arch in Snæefflesnes National Park (Arnarstapi). Using a wide-angle lens to slightly distort and elongate the arch, I added a 15-stop neutral density filter to create a 4-minute exposure, resulting in the surreal softness of the waves.

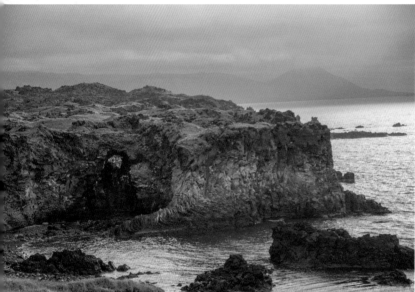

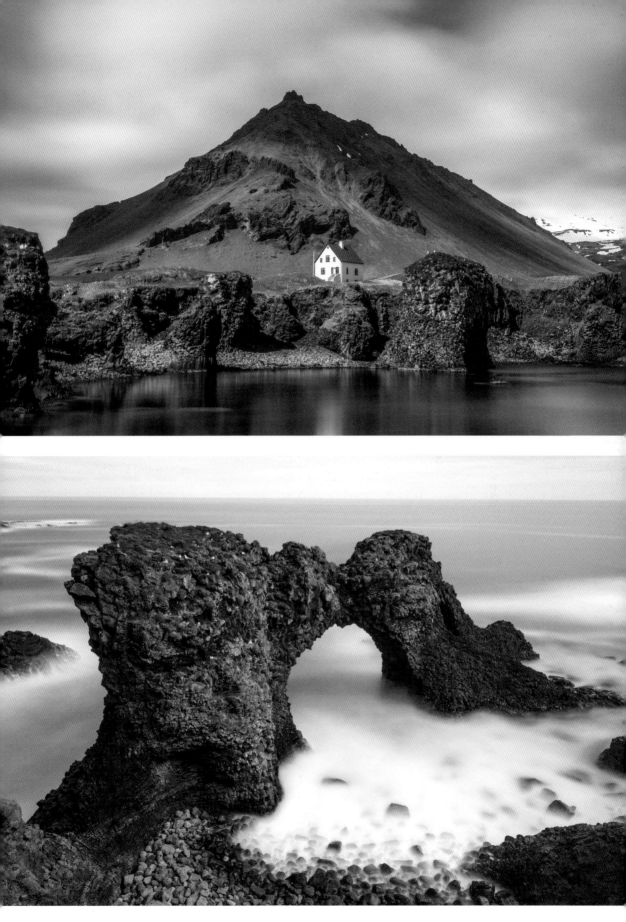

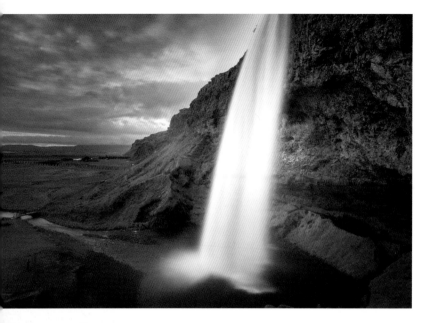

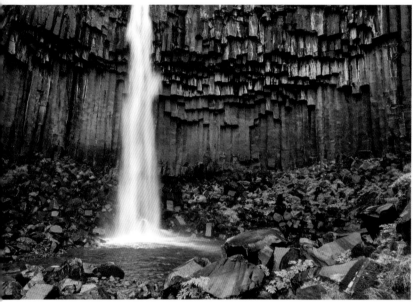

Seljalandsfoss

top—One of the most popular waterfalls on the south coast is Seljalandsfoss. Walking up a small hill on the right side of the falls gives one a nice angle, showing the hillside falling off into the distance.

following page—Summer in Iceland is adorned with fields of wildflowers. In order to include a large foreground at Seljalandsfoss, I chose a 16mm lens. This provided a greater sense of depth. The soft clouds and smooth waterfall are the result of adding a 10-stop neutral density filter to achieve a longer exposure (1 minute).

Svartifoss

bottom—Svartifoss, also known as Black Falls, is beautifully nestled into a cul-de-sac of basalt columns.

Due to increased tourist traffic, please honor any areas that are roped off, as they are there to protect the area and to keep it as pristine as possible.

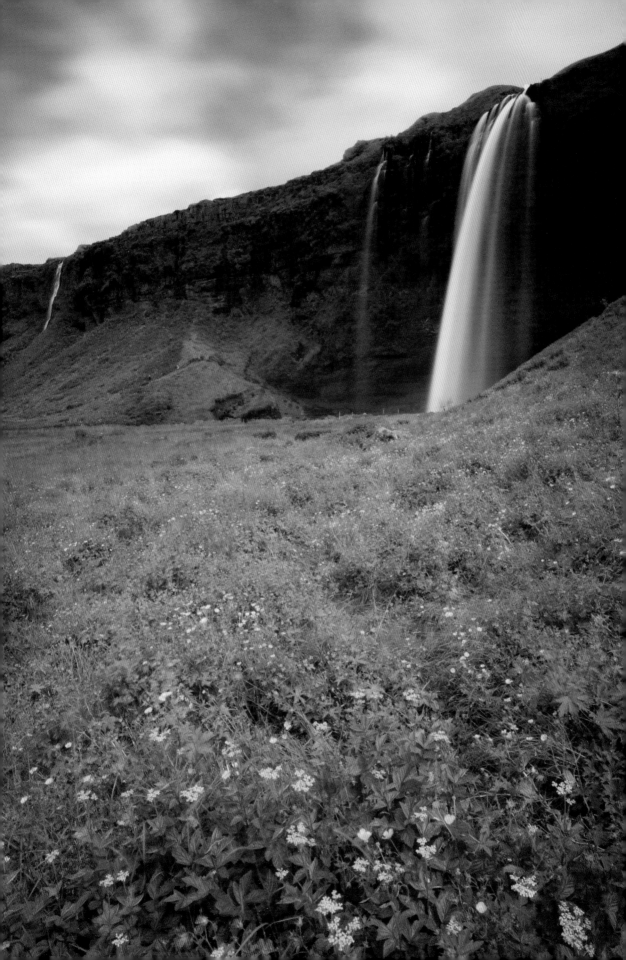

Öræfasveit

top left—The colors of summer in Iceland. Warm greens at the foot of this mountain are balanced by the overall cool tones in the rocks.

Lupine on Mýrdalssandur

top right—I came across a large field of lupine on a random roadside stop on the south coast of Iceland in mid July.

Late-afternoon clouds can be quite compelling. With the constant wind, I had to raise the ISO to 800. I had to shoot at f/14 instead of f/16 or f/22 to use a high enough shutter speed to arrest the movement of the flowers as much as possible, and achieve an acceptable image quality.

By Kirkjubæjarklaustur

bottom—There are many large areas of wildflowers along the south coast in the summer. Here, we found a large field of red and yellow hawkweed, with quintessential Icelandic green hills in the background, and blue sky.

Whenever I can find it, I try to include red, green, and blue in the image for maximum color impact.

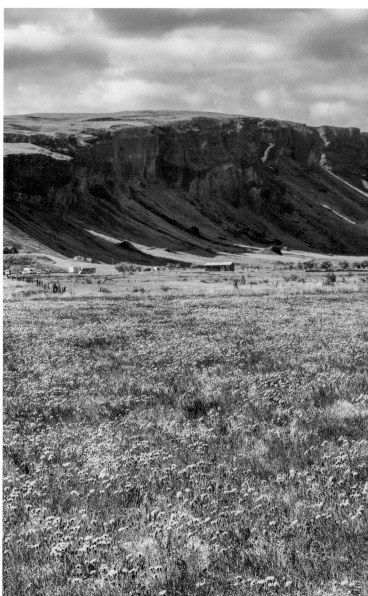

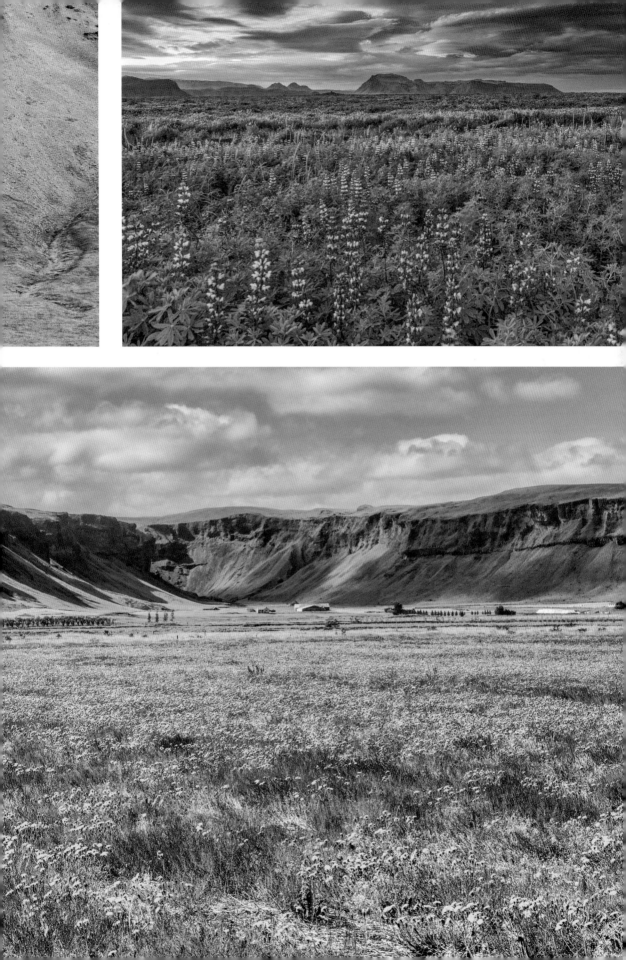

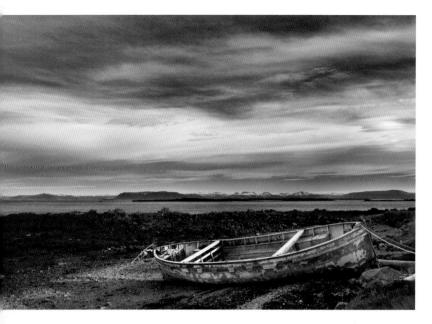

On Flatey Island

top—This image is from Flatey Island in the Westfjords of Iceland. This idyllic island is a vacation spot for Icelanders; it is also an arctic tern sanctuary.

On Mælifells Sand

bottom—There are many winding roads throughout Iceland. This image was photographed driving back to Reykjavík from Snæfellsnes National Park.

Ice on Jewel Beach

following page, top—At the far end of Jewel Beach, this large ice chunk, approximately 6 feet long, stood alone in an area of small rocks.

This beach can be crowded, but the farther you walk down the beach, the more isolation you will find.

following page, bottom—One of the great effects when photographing on Jewel Beach is to get the water trails as the ocean recedes around the ice chunks. Using a neutral density filter can slow the exposure enough to create the water lines. An exposure of 2 to 3 seconds is a good starting point.

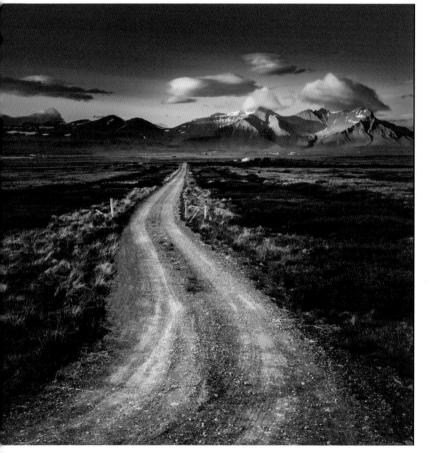

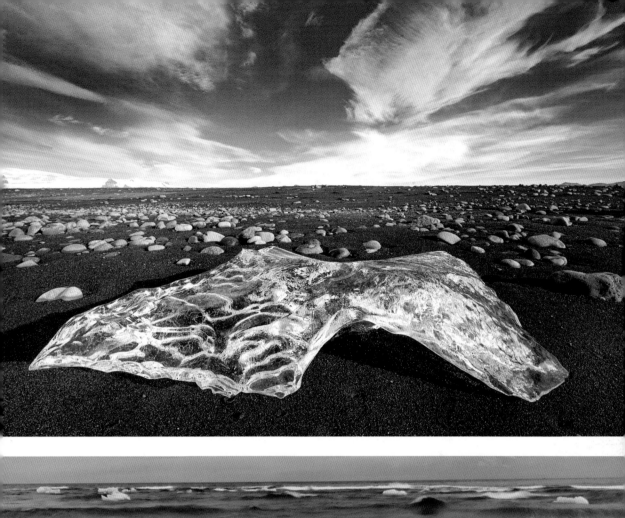
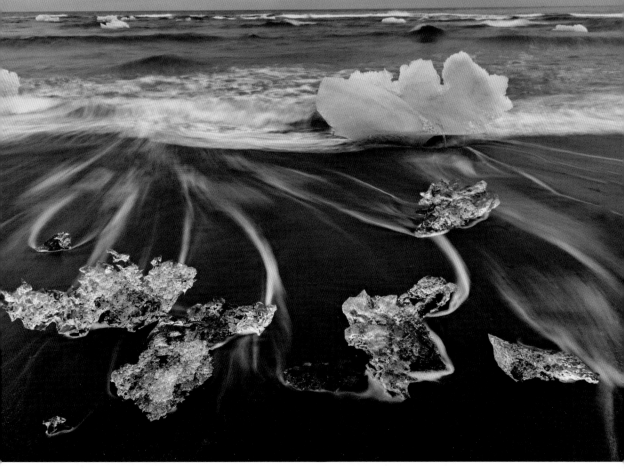

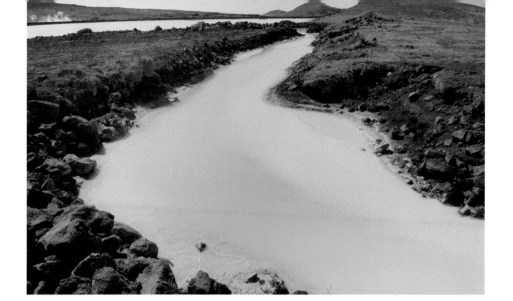

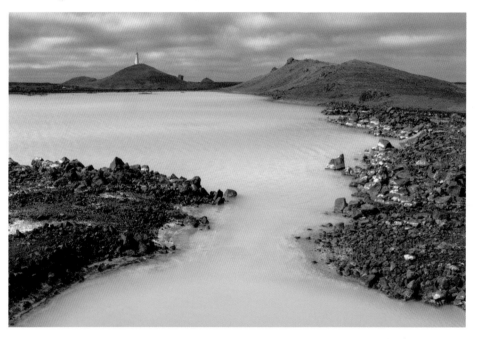

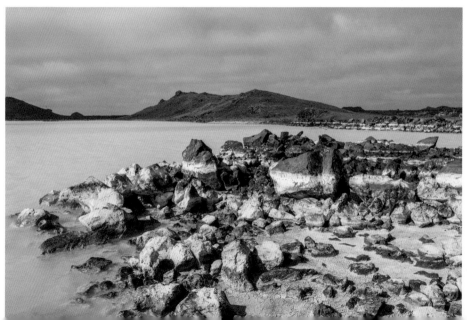

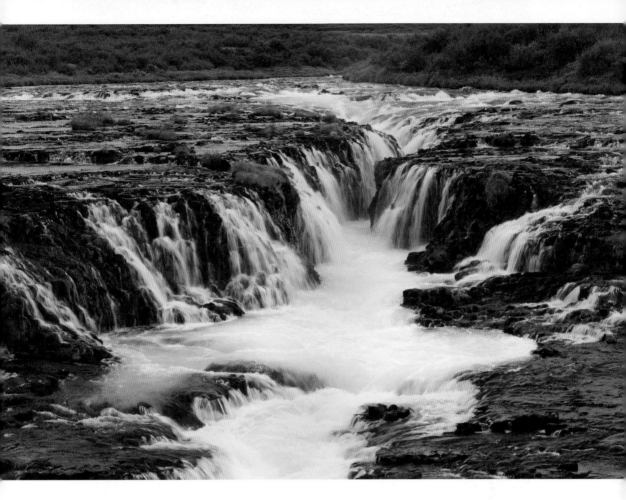

Reykjanes Lighthouse

previous page, top—The power plant between Keflavík and Reykjavík is large, steamy, and futuristic looking with turquoise (sulfur) water. In this image, I used the long, curvy line to lead the eye to the lighthouse.

previous page, center—One can walk around this sulfur lake to find interesting leading lines to the lighthouse. In this case, a large S-curve easily pulls the viewer through the image.

One cannot walk around these facilities anymore. Because of abuse by visitors and photographers, there is no longer public access to this place.

Moral: Treat these places as you would if you lived there, or an increasing number of these locations will become inaccessible.

previous page, bottom—The sulfur on the exposed rocks created a strong foreground to the sulfur lake and distant hills.

Bruarfoss

above—One of our favorite waterfalls in Iceland is Braurfoss. Whenever a word ends in "foss," that means that it is a waterfall.

The view is great from the footbridge. A little exploration will yield other angles of view, but beware: wet rocks are very slippery, and walking on them should be avoided.

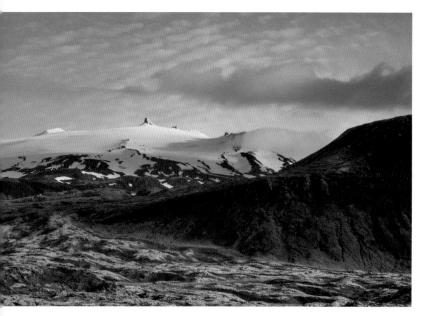

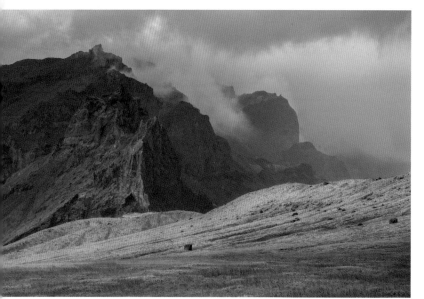

Snæfellsnes Glacier

top—The combination of snow-capped mountains and summer greens makes for a wonderful palette. The foreground is a lichen-covered lava field, many of which are viewable from the roads throughout Iceland.

South Coast

bottom—This image was made along the south coast with a low-angle sun, approaching sunset. Of course, there is no sunset in the summer. There are 20 hours of light and 4 hours of dusk. This quality of light can last for a long time in Iceland; it lasts a much shorter period of time at lower latitudes.

By Svinafell Glacier

top—This scene is from along the south coast. Tours are often crowded at the classic locations, but these types of small scenes are everywhere along the coast and throughout Iceland.

Fossalar on Sida

bottom—This rushing river is located along the south coast. The smooth water was created by adding a 5-stop neutral density filter to allow for a 2-second exposure.

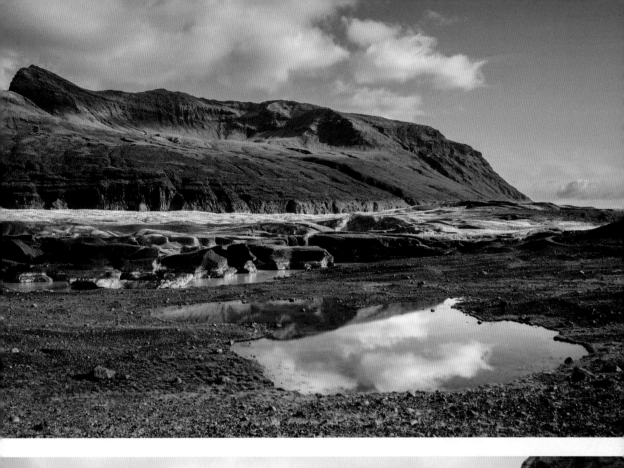
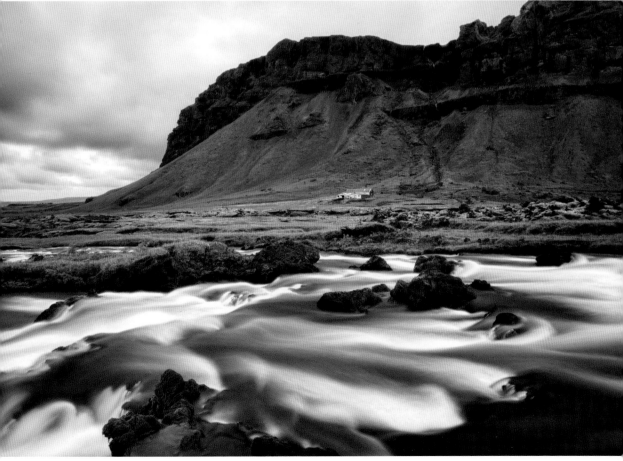

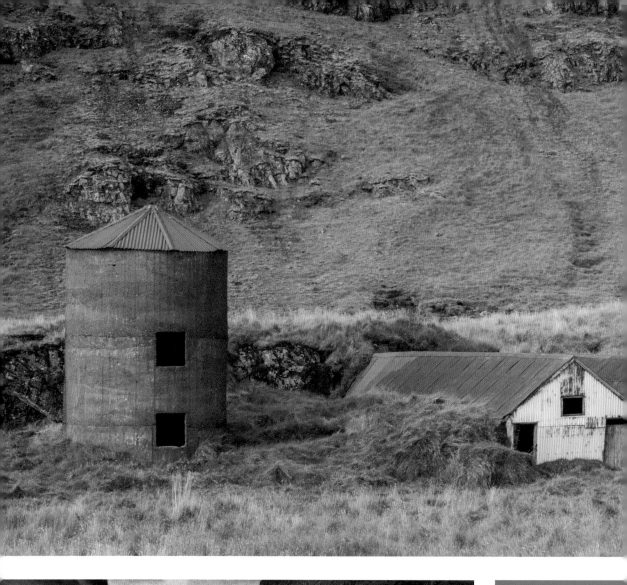

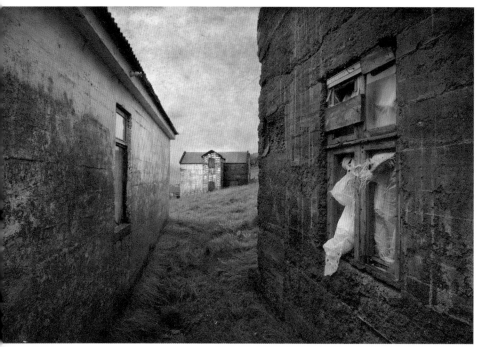

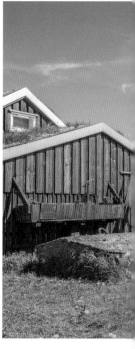

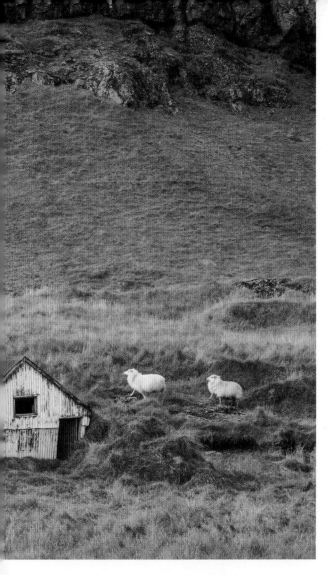

Uppsalir: Abandoned Farm

top—A favorite grab shot along the south coast are these old structures with a cylindrical brick barn.

On this day, we were lucky to have a couple of sheep enter the scene. I took several images, but only one caught the sheep with their legs in a good position.

When photographing wildlife, be sure to make many images, as the slightest changes in movement, posture, and position can greatly affect the photograph.

Hólmur: Abandoned Farm

bottom left—Old farms, barns, and structures are a favorite subject in Iceland.

The original image had a white sky, which is not desirable for landscape/outdoor photography in general. However, white skies are perfect for adding a texture. That is the case here.

Flatey Island

bottom right—All of the parts fell into place in this image from Flatey Island. Here are the compositional elements: The houses create a frame within the frame. The clothesline opening, woodpile, and single cloud frame the distant single house, drawing the viewer into the scene.

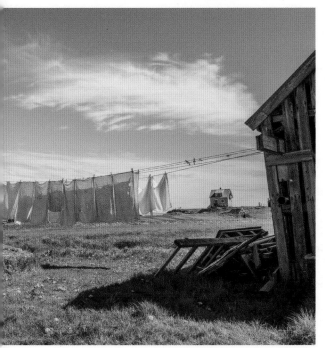

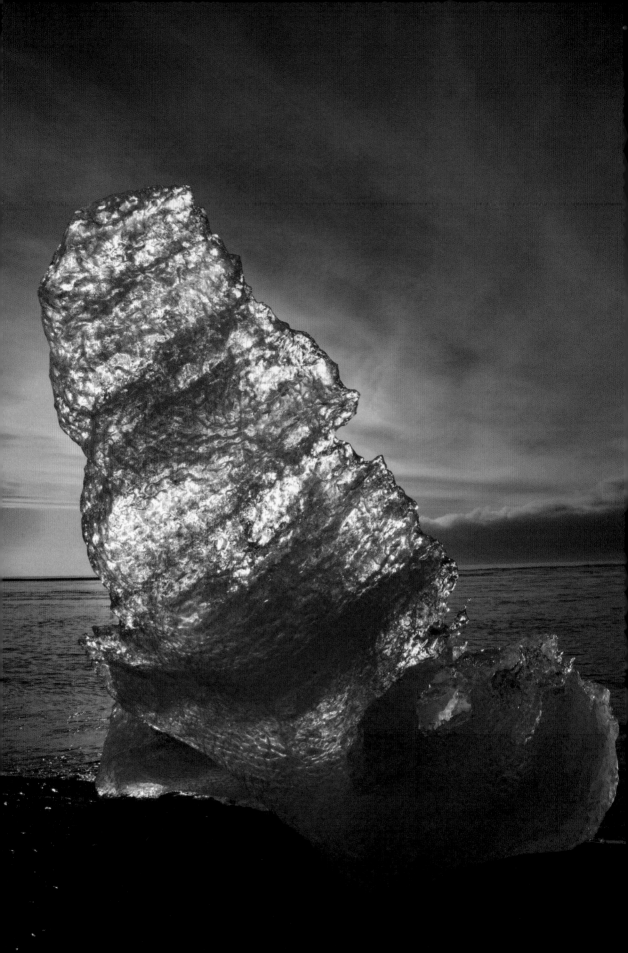

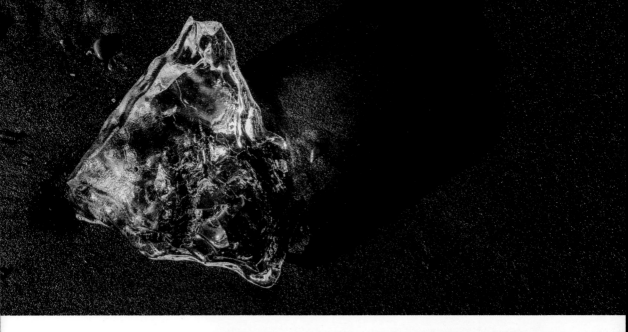

Ice on the Beach at Jökulsárlón

previous page—Low-angle sunset on Jewel Beach is a great time to compose in order to backlight the large ice formations.

 top—A triangular shaped "diamond" on Jewel Beach stands out against the black sand. Lit by the bright, low-angle sun, the contrast and texture are maximized.

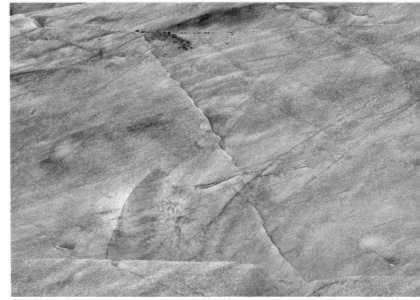

Svinafell Glacier

bottom—A turquoise variation in a wall of ice.

Helgafellsveit
on Snæfellsnes Peninsula

top left—Patchy light on the Snæffle-sness Peninsula.

Fajrdrárgljúfur Canyon

top right—Fjadrárgljúfur Canyon in south Iceland is one of many canyons and gorges in the country.

Örævajökull

bottom—After several days of rain, there were mirror reflections all along the south coast road. This is an eleven-image stitched panorama.

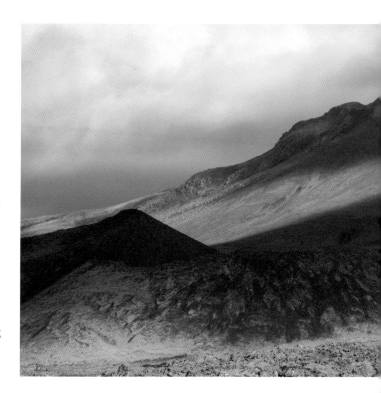

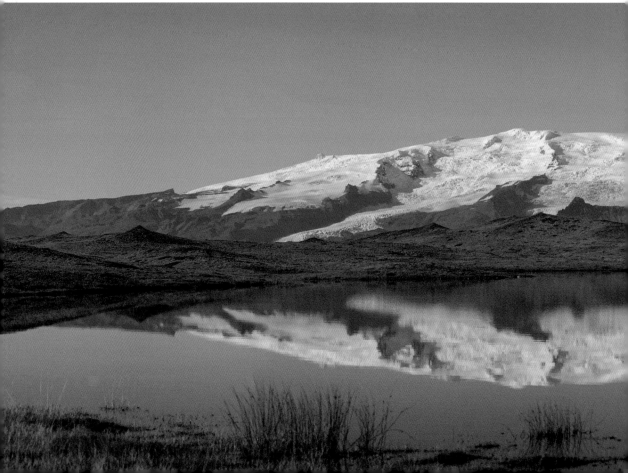

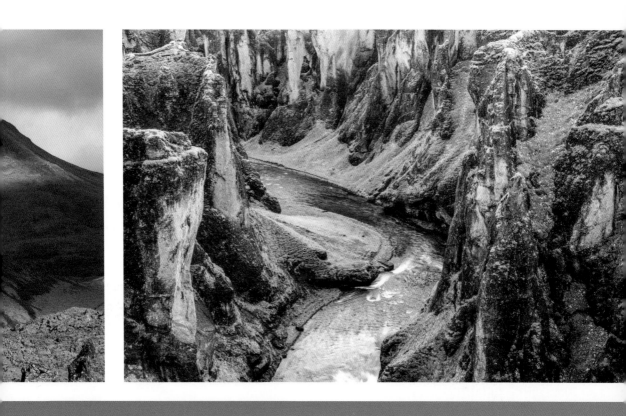
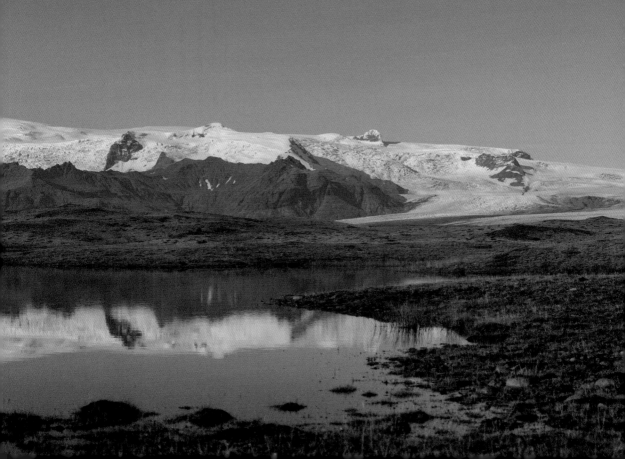

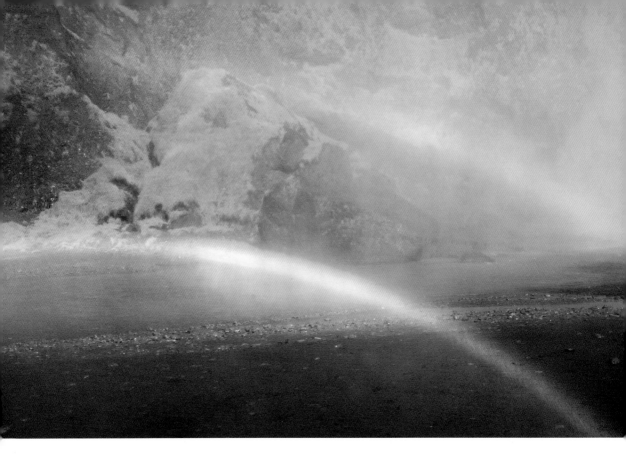

Under Skógafoss

above—I ventured very close to Skógafoss and was only able to photograph this bold double rainbow under the falls when the wind shifted temporarily. I got drenched several times during the process. A waterproof jacket, waterproof pants, and waterproof shoes were essential.

Fall Color at Gjáin in Thjórsárdalur

following page, top—This image was shot from a parking area during a persistent drizzle to horizontal rain, resulting in raindrops on the lens in every image.

There are hiking trails down to and throughout the gorge.

following page, bottom—The double rainbow appeared at Gjáin during the heaviest blowing rain. The lenses were getting water spotted almost instantly, no matter how we hid the camera until ready to take the picture. I took many photographs of this scene, and this image is the one that needed the least number of waterdrops removed using Photoshop.

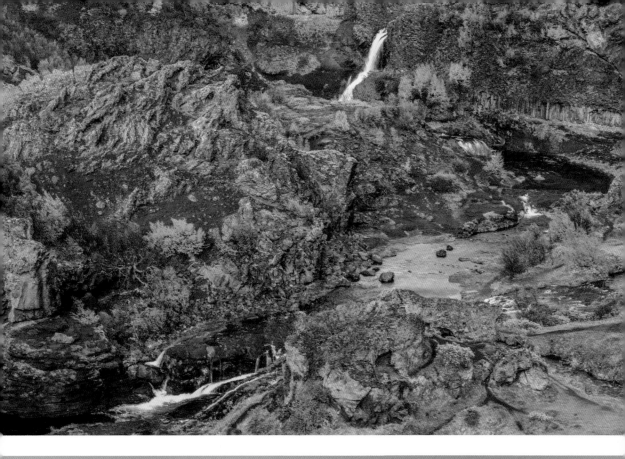

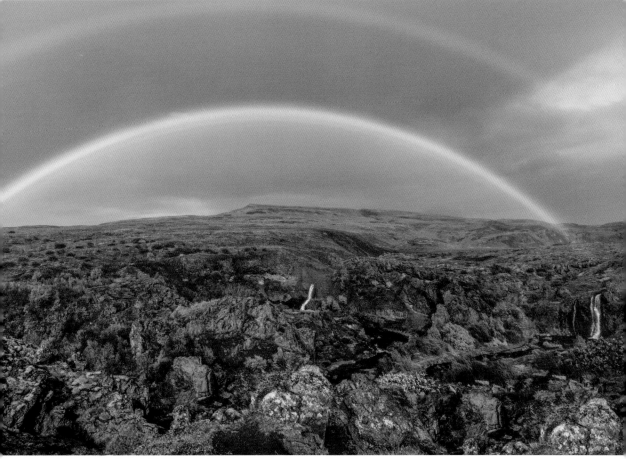

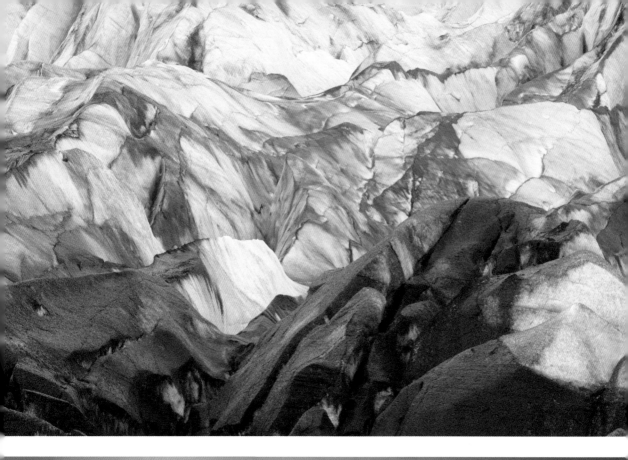

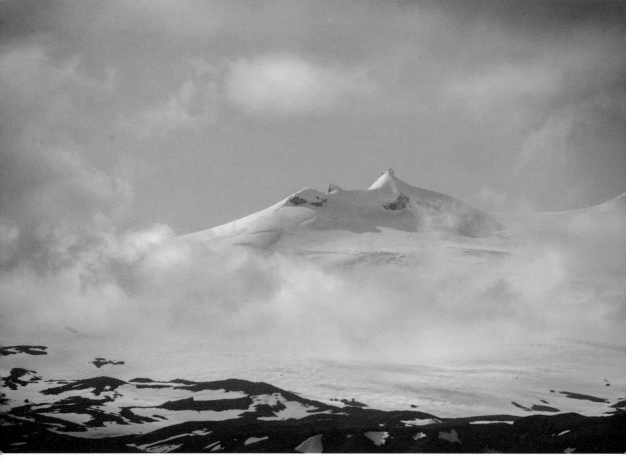

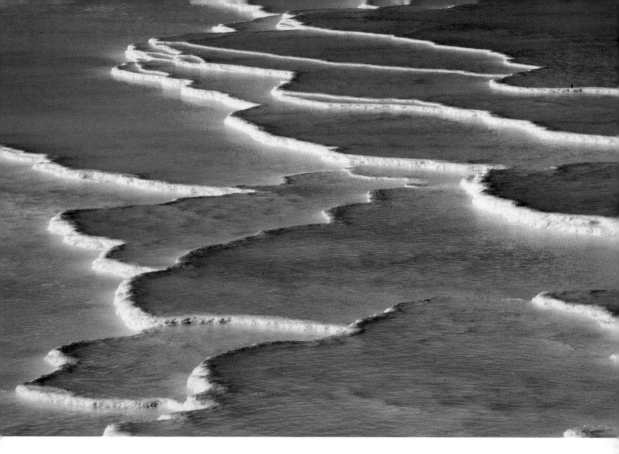

Svinafell Glacier

previous page, top—It's a good idea to begin with a wide-angle lens to encompass the whole subject, but it can be more interesting to use a longer lens to reach in to pull out smaller scenes. For this image, I used a 300mm lens to reach far into the glacier to fill the frame with this abstract ice pattern.

 previous page, bottom—Snow-capped mountain on the northernmost part of the Snæffle-snes Peninsula.

By Svartsengi Geothermal Plant

above—Sulfur pattern near the famous Blue Lagoon. The low-angle sun accounts for the bright front edges of the pattern.

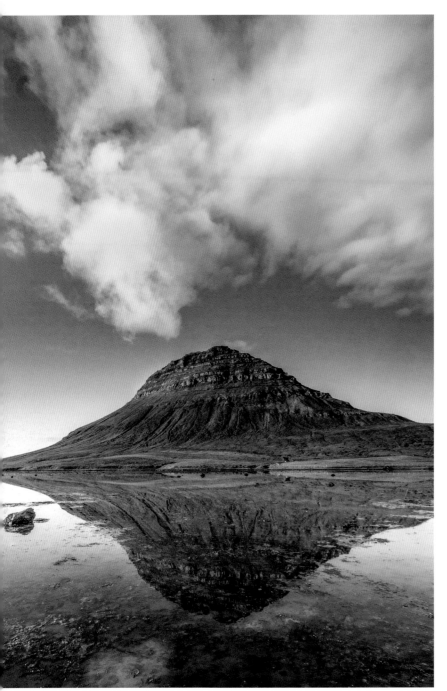

Kirkjufell on Snæfellsnes Peninsula

left—A mirror reflection of iconic Mt. Kirkjufell on the Snæfflesnes Peninsula.

In Fajrdrárgljúfur Canyon

following page—An unnamed runoff into a deep gorge. This image was made on a 26-hour trip through the Iceland interior.

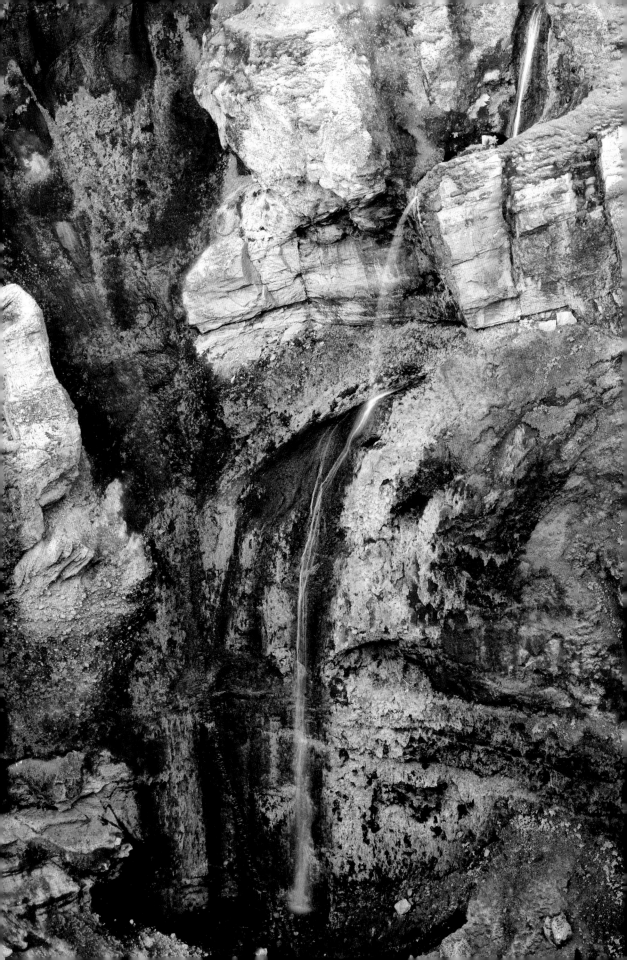

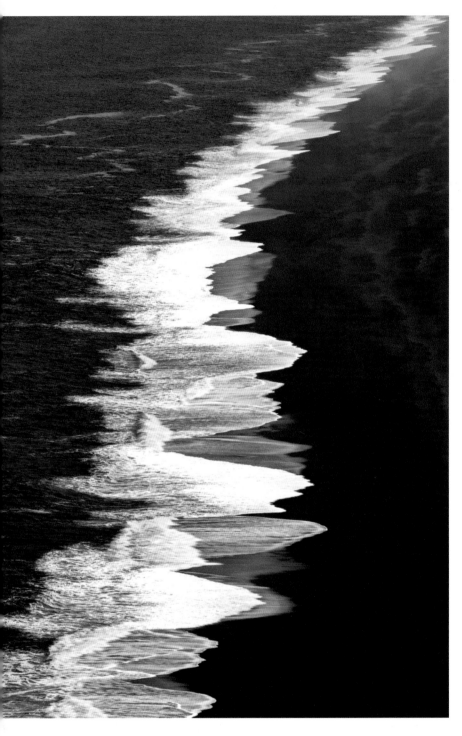

Beach from Dyrhólaey

left—This image was made from the highest point in Vík, then made into a high-contrast black & white image, accen tuating the backwash on the black-sand beach.

Drangur by Reynisfjall

following page—Reynis-drangar, in Vik, is one of the most prominent sea stacks in south Iceland. I was able to get close at low tide to set up to make this composition. A 4-minute exposure, using a 15-stop neutral density filter, accounts for the smooth ocean.

Halfway through the exposure, the tide began to rise quickly. The ocean was encroaching on my tripod at the end of the exposure. Be circumspect and always have an escape route.

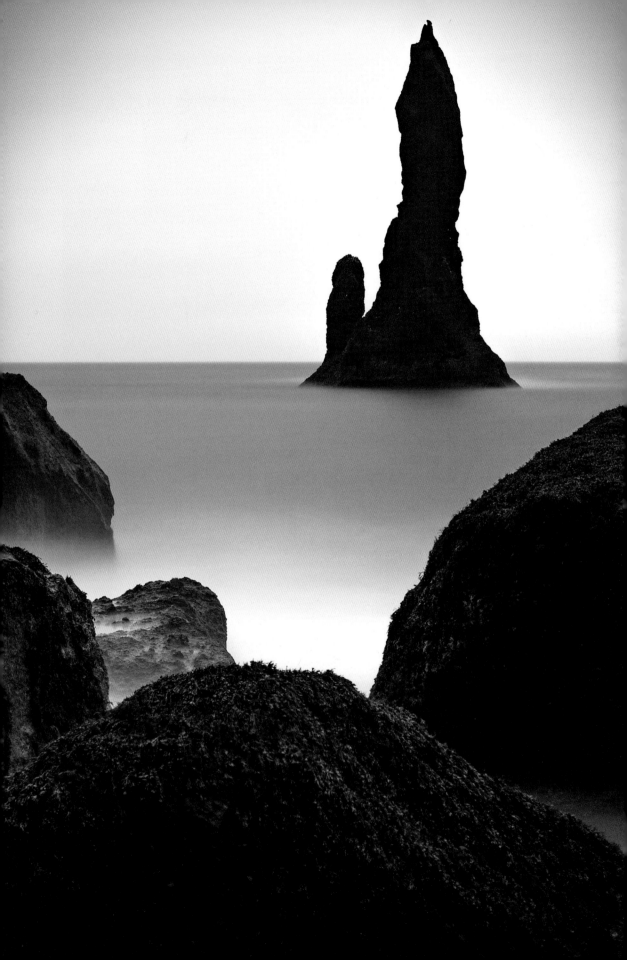

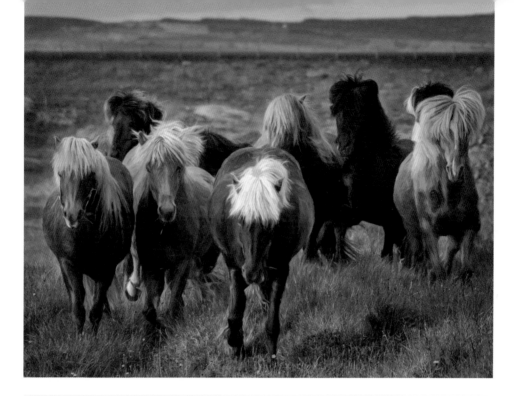

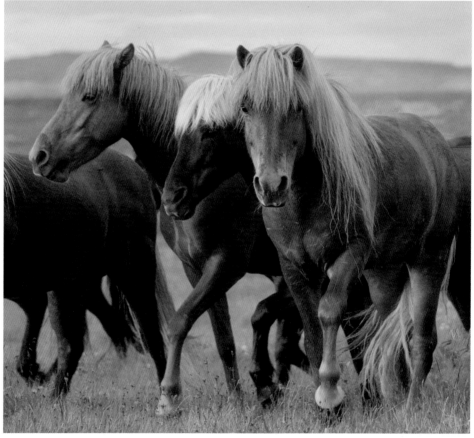

The Horses of Mýrar

The equine population on Mýrar make for wonderful portrait subjects.

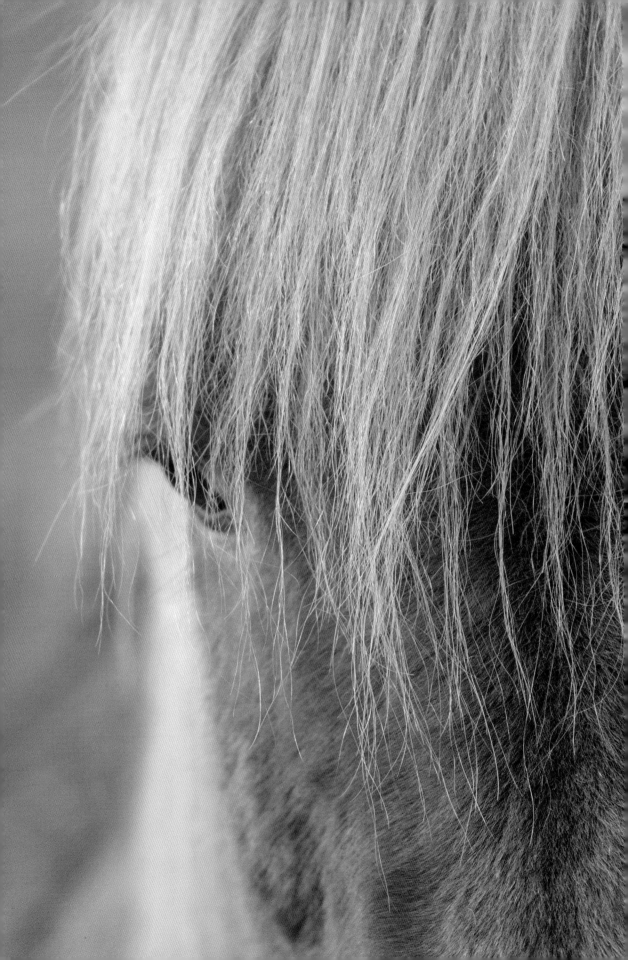

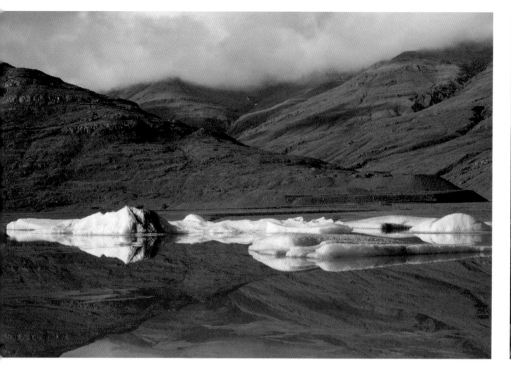

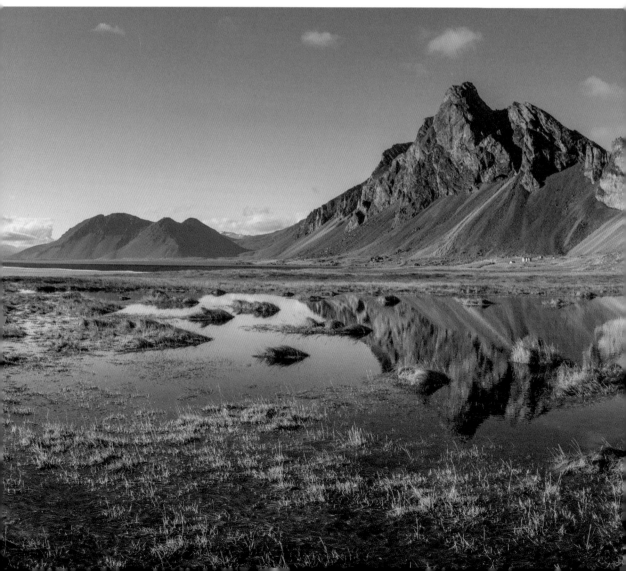

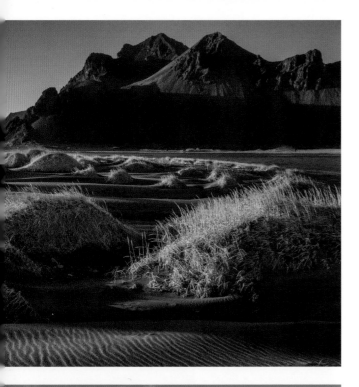

Ice on Fjallsárlón Lagoon

top left—This is one of many lagoons along the south coast, particularly interesting when the mountains are clear of snow and there are only ice chunks and the distant mountains mirror-reflected in the still lagoon.

Sand Dunes by Vestrahorn

top right—Vestrahorn on the Stokksnes Peninsula is another iconic location frequented by tourists and photography workshops. With the tufts of golden grasses along the coast and dramatic angular light, this is a great subject to visit at any time of year.

By Eystrahorn

bottom—This is a five-image stitched panorama. These reflection pools are great when you find them, especially when they reflect a great subject.

 Note: Reflection pools are fleeting and could be gone in a matter of hours.

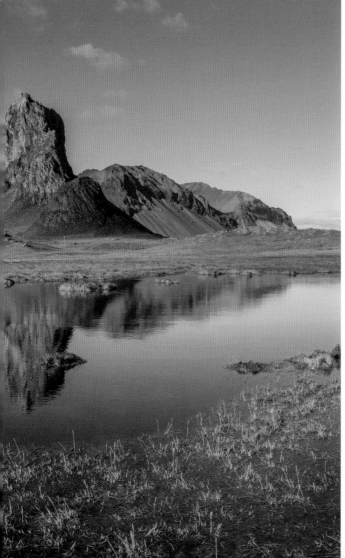

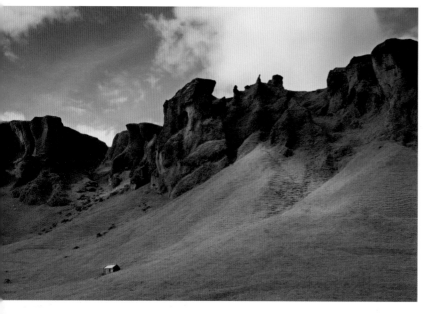

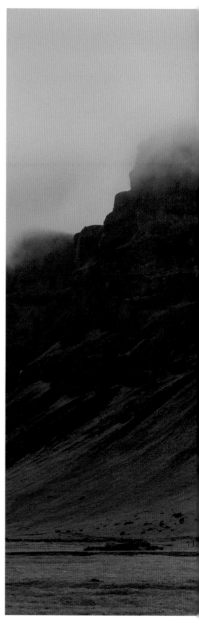

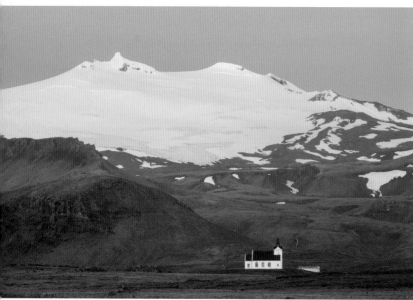

By Foss a Sidu

top—The scale of Iceland can be breathtaking. This image was made at one of our favorite locations on the south coast, Foss a Sidu. The small power shed is dwarfed by the unusually shaped, domineering rocky hills, giving a great sense of scale.

Church by Rif at Snæfellsnes

bottom—This image was made at the uppermost tip of the Snæfflesnes Peninsula. Even in summer, there are snow-capped mountains. This photograph was made at about 2:00am in July.

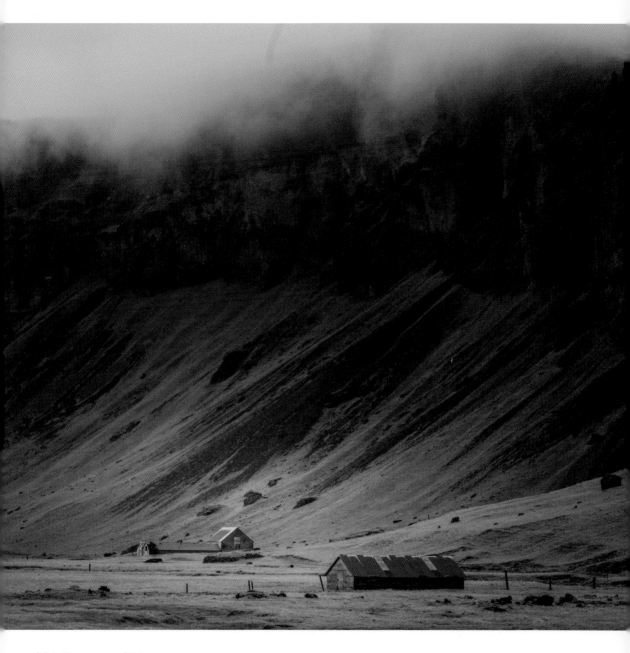

Old Barn at Sída

above—A family farm on the south coast, overwhelmed by the enormity of the protective mountain, and spotlit by a ray of diffused sunlight.

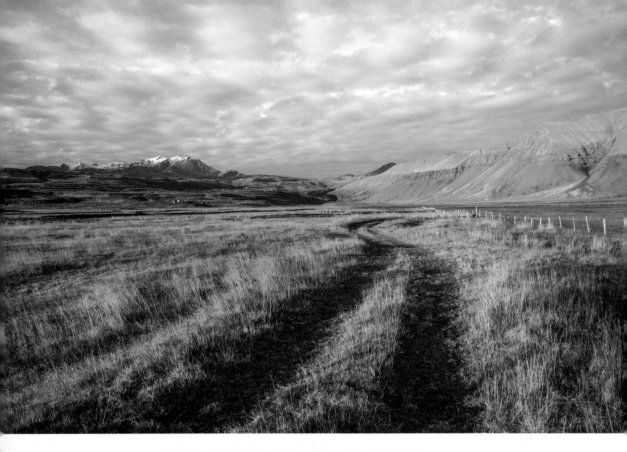

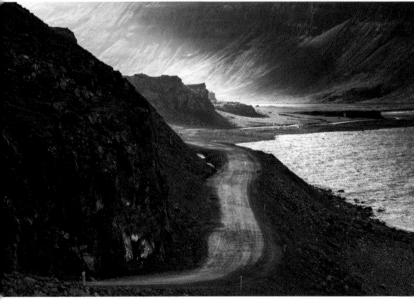

By Skaftá River in Eldhraun

top—One could stop almost anywhere in Iceland to take a picture. The late-afternoon light can last for an hour or longer, unlike at lower latitudes.

The S-curve in the dirt road is a strong leading line.

On Strandir in Westfjords

bottom—The Westfjords of Iceland is a rugged and interesting drive along the coast and at the base of mountains, with winding roads, yielding many photo ops of lesser-traveled areas.

Gullfoss Waterfall

top—Gullfoss is referred
to as the Niagara Falls of
Iceland. Walking all the way
up to the rock platform and
shooting at a short expo-
sure ($^1/_{15}$ or $^1/_8$ second, for
example), one gets a feel of
the power and volume of
water passing through. This
image was made as close as
I could get to the falls, from
behind a chain-link fence.

 bottom—This image is
a much longer exposure
(30 seconds) of Gullfoss.
It smoothed out the water
and completely changed the
feel of the scene.

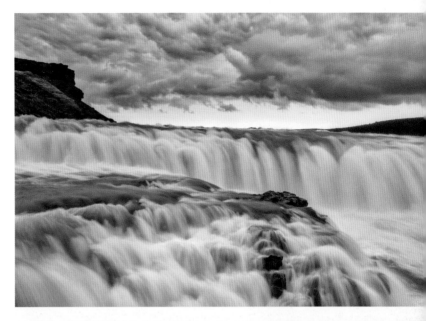

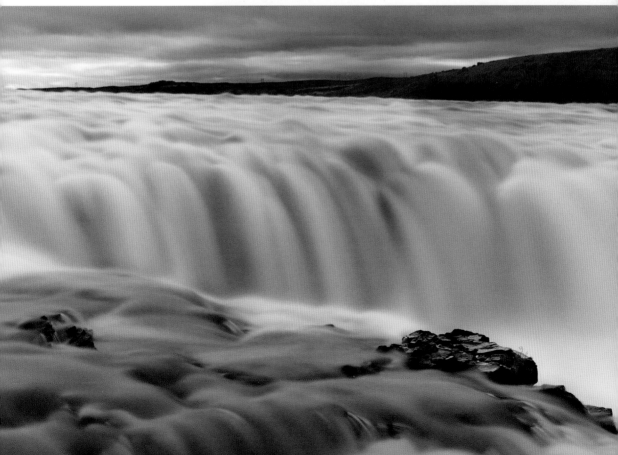

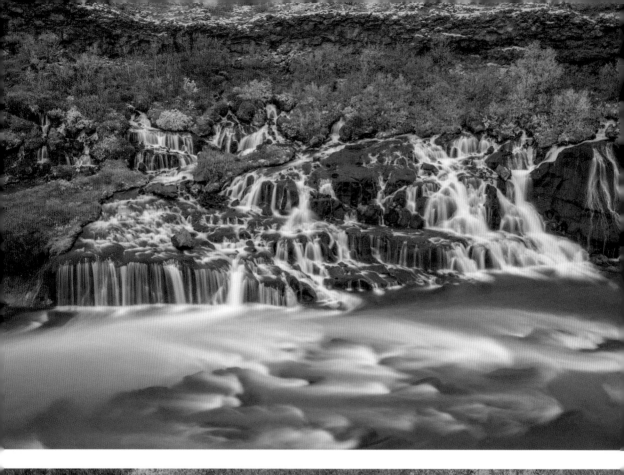
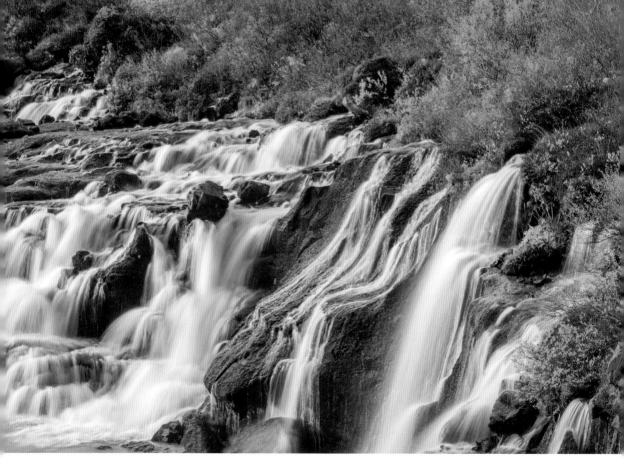

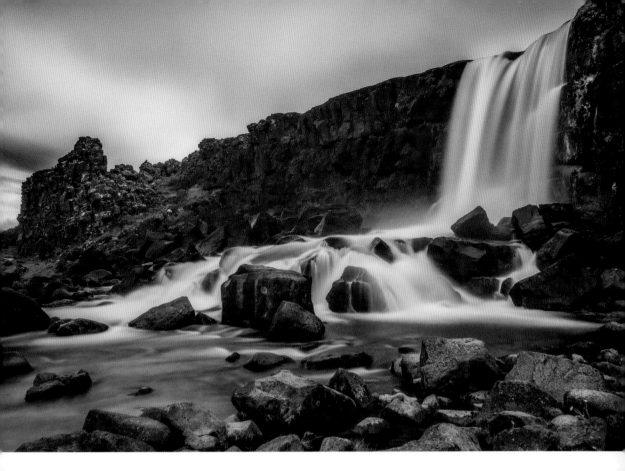

Hraunfossar Waterfalls

previous page, top—In September, fall color and turquoise rapids frame these small waterfalls emanating from an underground source. Photographed from an overlook by the parking lot. Easy access, close to the parking lot.

previous page, bottom—Hraunfossar in late-afternoon light. Image made from a boardwalk, easily accessible. The fall color is intensified by the warm, low-angle sunlight.

Öxarárfoss Waterfall at Thingvellir

above—Waterfall at a crack in the earth, made from a boardwalk. There are several tectonic plates which come together in Iceland, exemplified by this image of the Öxarárfoss waterfall in Thingvellir National Park. There is easy access for tourists and photographers with tripods.

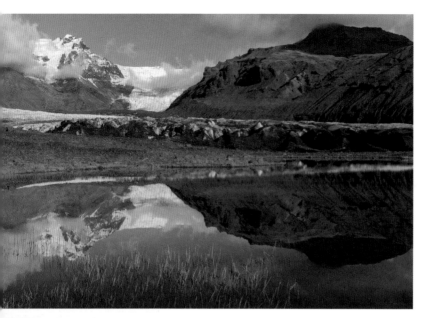

South Coast Glacier Lake

top—Normally, bright, sunny days are not ideal for nature/landscape photography. However, in Iceland, the light is clean and unpolluted. The blues are deeper in color because of the northern latitude. Photographing in strong sunlight can render bright, colorful images.

Turf Houses

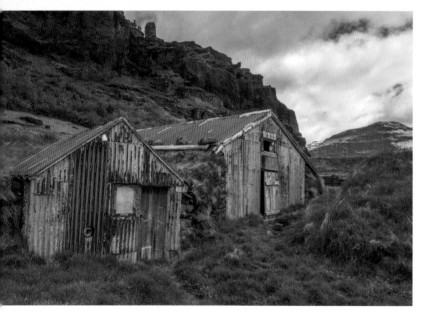

bottom—These sheds are built into the side of a hill for insulation. This is an HDR image. Several images were made at different exposures, then blended in HDR-specific software (Aurora HDR from Skylum Software).

Jökulsárlón

following page, top—This image illustrates the enormity of the glacier, juxtaposed with the boatman at the bottom-left corner of the frame.

following page, bottom— Ice on the beach. One of the fun things to do with moving water is to try various shutter speeds, as more than one shutter speed may be acceptable. In this image, a 1-second exposure resulted in the cotton-candy effect on the incoming waves and the lines of the receding waves.

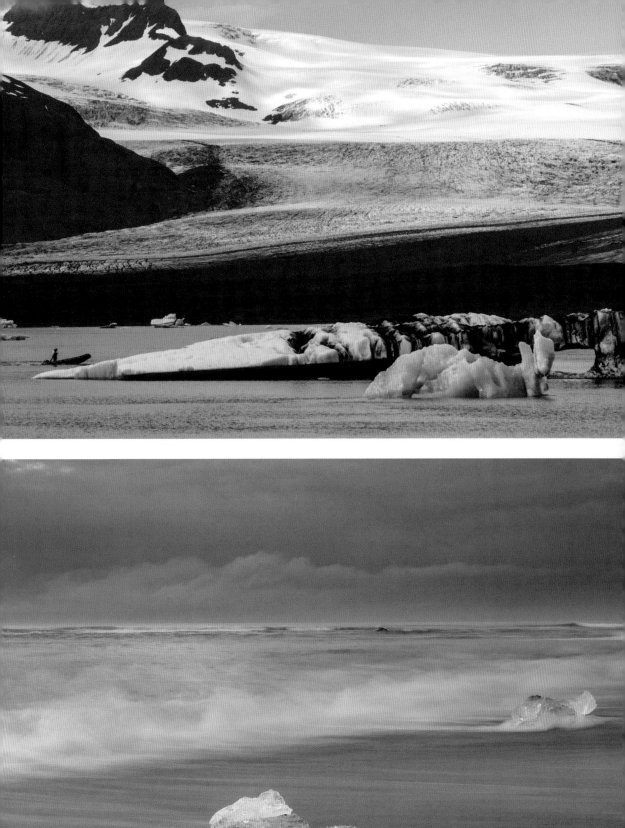
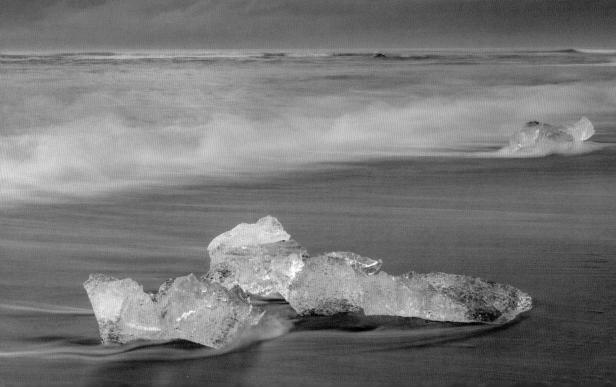

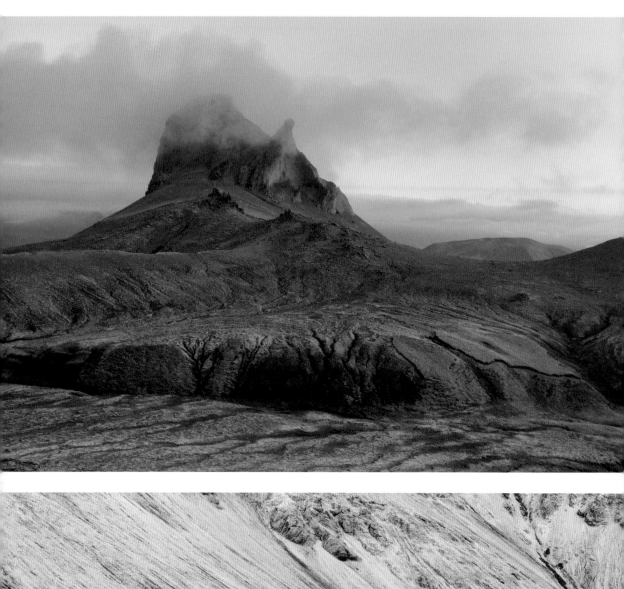

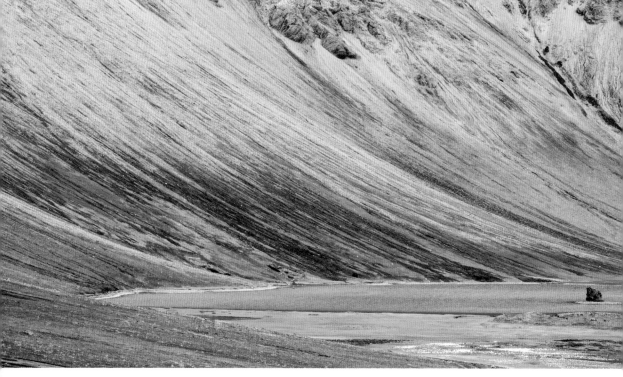

Einhyrningur

previous page, top—Deep in the Iceland interior is one of our favorite mountains, Einhyrningur, also known as The Unicorn. This image was made during a 26-hour drive off the beaten path on our first workshop in Iceland.

Icelandic Highlands

previous page, bottom—A pastel interior and lake of a dormant volcano in the Icelandic highlands.

 top—Another image from our trip into the Icelandic interior. Being a volcanic island, there are volcanoes everywhere, most of them dormant.

 Note: Most roads across the Iceland interior do not open until July.

Thermal Springs

bottom—In the summer, aside from the underground thermal springs, parts of Iceland can look similar to Hawaii. The rich greens and dark-red soil are evocative.

 This was photographed from an overlook. There's easy access for everyone.

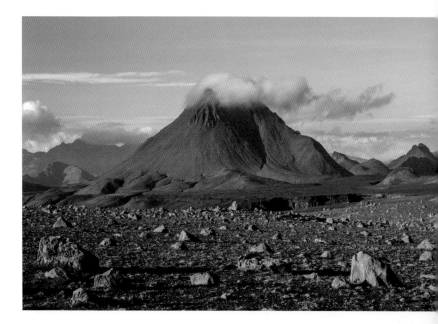

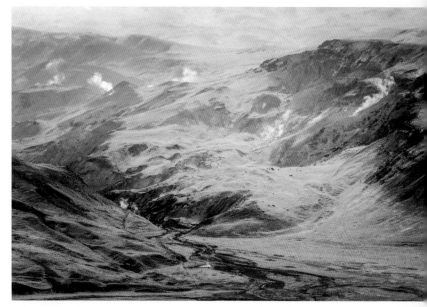

Námaskard, East of Mývatn

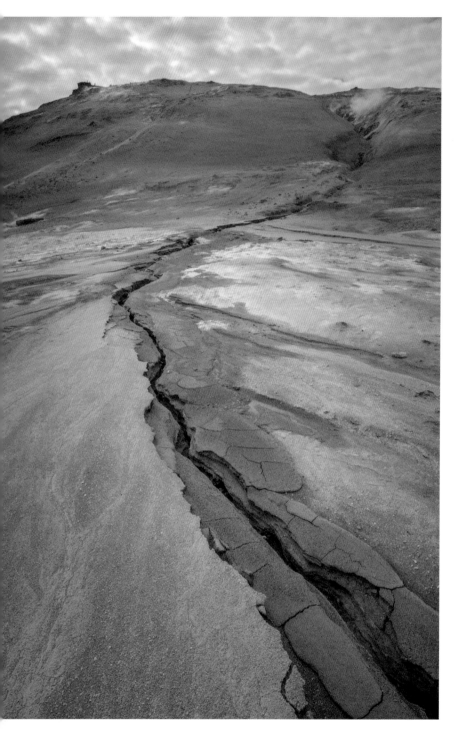

left—The stark appearance of this landscape, the colorful mineral deposits, and thermal steam are easy to photograph, and the terrain is flat and easily navigable for all.

A wide-angle lens was used to exaggerate perspective and give a sense of depth in this photograph.

following page—Another image made at the same location.

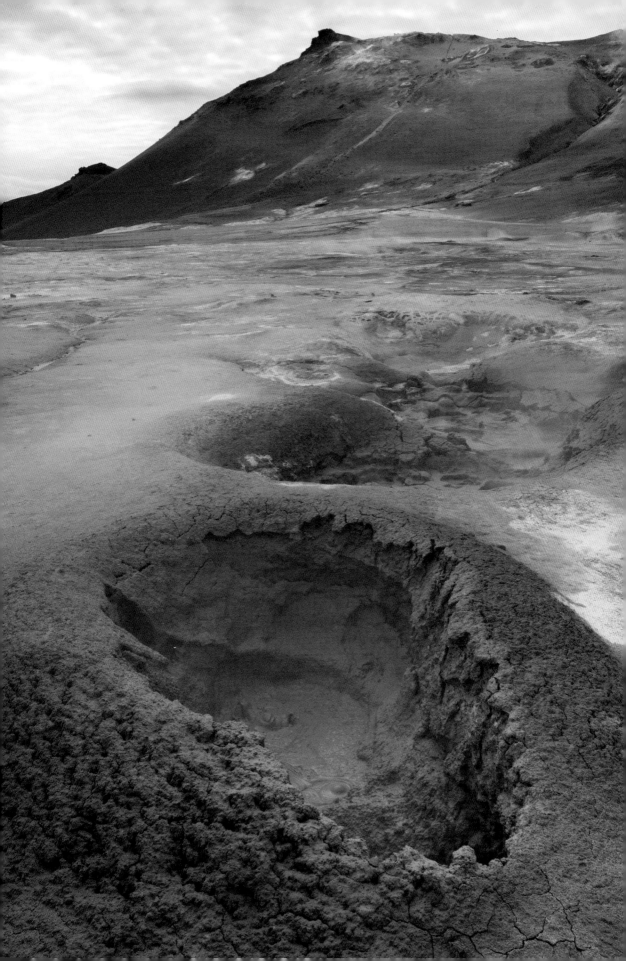

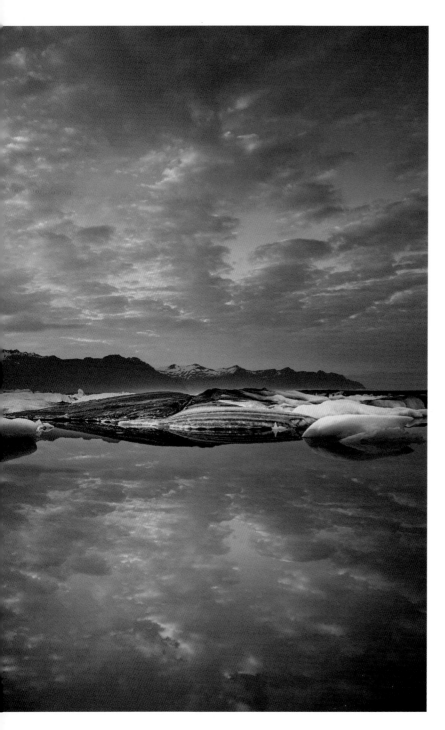

Fjallsárlón

left—A perfect mirror reflection at a lesser-known glacial lake along the southeast coast.

Taking side roads off the beaten path can often lead to images and scenes that are out of the ordinary.

Snæfflesness National Park

following page—The lush greens are indicative of summer in Iceland. This image was made during our drive to Snæfflesness National Park. I'm always on the watch for curved lines to lead the viewer into the frame. In this case, I used the small S-curved stream as a leading line.

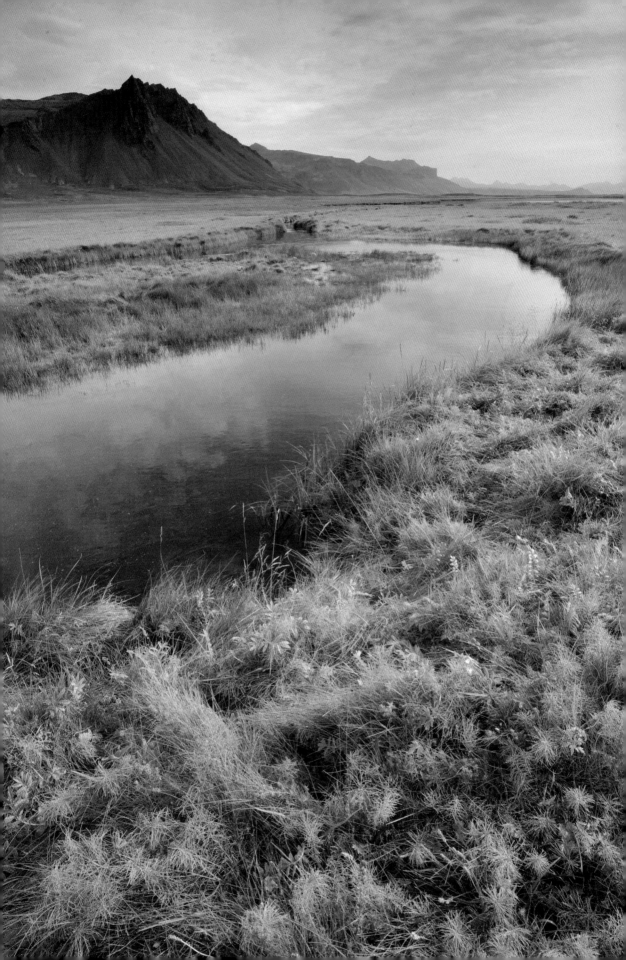

Jökulsárlón: Three Takes

top left—Blue ice in Jökulsárlón. Why blue ice? Glacial ice is a different color from regular ice. It is so blue because the dense ice of the glacier absorbs every color of the spectrum except blue, so blue is what we see.

top right—This image shows the underside of a blue iceberg in the lagoon. With my 36mp camera, I was able to dramatically crop the image, yet ensure enough resolution to maintain quality to print.

bottom—A black & white rendering shows more of the graphic quality and textures of the ice in this glacial lagoon. Jökulsárlón is a very popular tourist and photographer venue. It's not uncommon to be among a large number of people. However, the lagoon is large enough that there is plenty of room to photograph without anyone getting in the way.

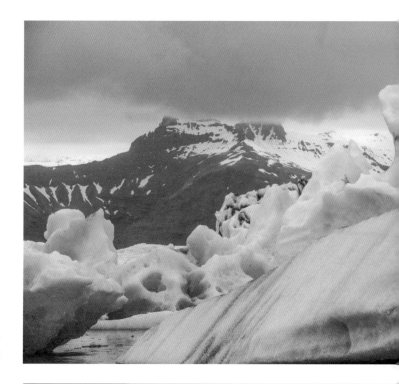

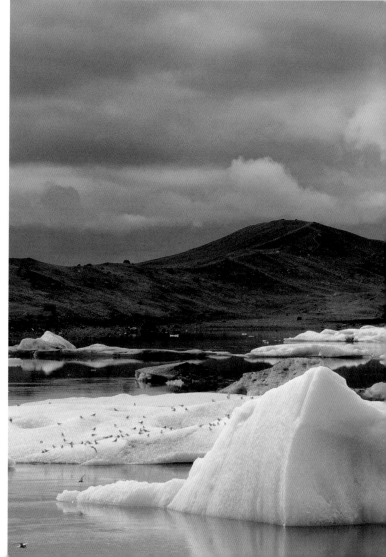

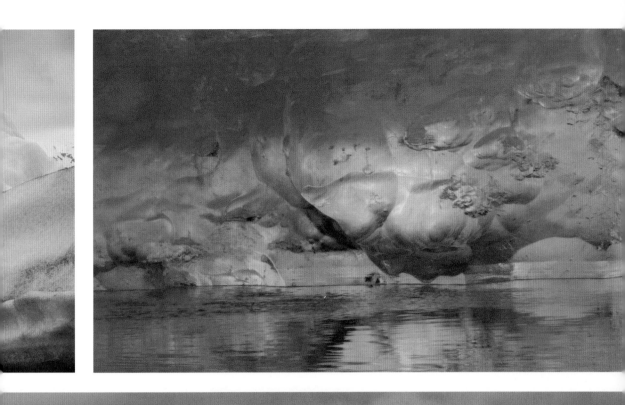

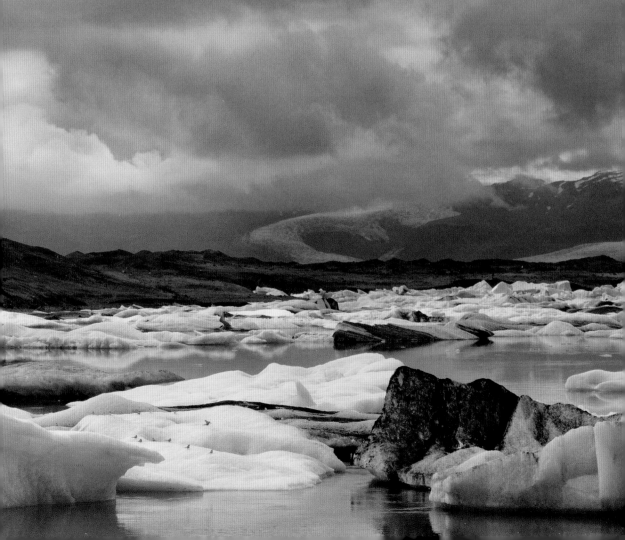

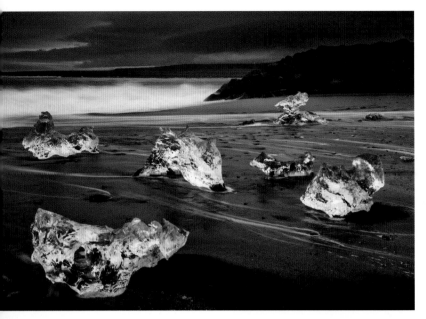

Ice on Jewel Beach

top—Here, I used a longer exposure to blur the incoming waves, while keeping the ice separated on the black sand, creating a high-contrast subject area with strong visual impact.

bottom—I used a variable neutral density filter to experiment with different shutter speeds to find the right one to create the water streaks around the ice chunks, as the ocean recedes. This water flow was created by a 3-second exposure.

Hvítserkur

following page, top—I love to photograph sea stacks, and Iceland has two of my favorites. The smooth water is the result of a 2-minute exposure using a 10-stop neutral density filter.

Dyrhólaey and Reynisdrangar

following page, bottom—The foreground subject is another of my favorite sea stacks in Iceland: Dyrhólaey. The high key processing and 4-minute exposure add to the surreal feel of this scene. In the distance are the sea stacks in Vík (Reynisdrangar).

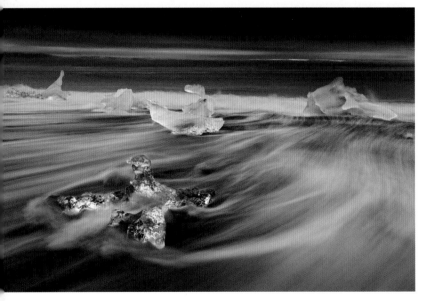

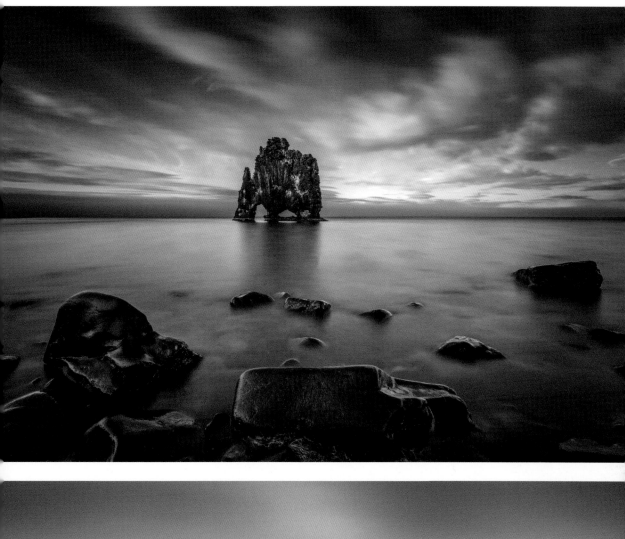
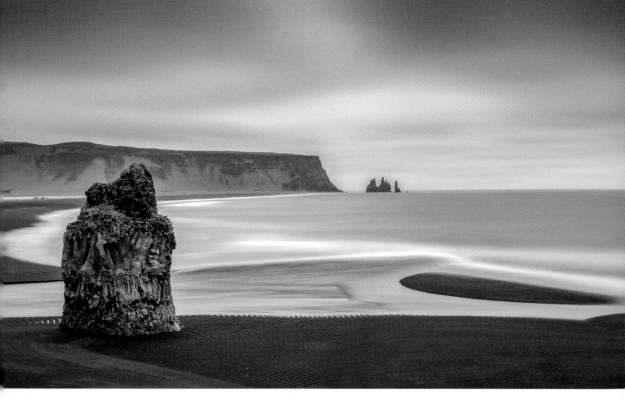

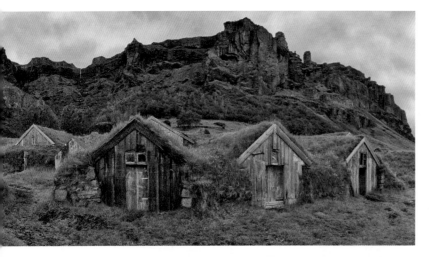

South Coast Turf Houses

top—Icelandic turf houses were the product of a difficult climate, offering superior insulation.

This is a particularly good configuration, with the houses filling the frame, the graphic background hills, and overcast sky. I needed a multi-image approach to even out the exposure and bring in detail throughout the image.

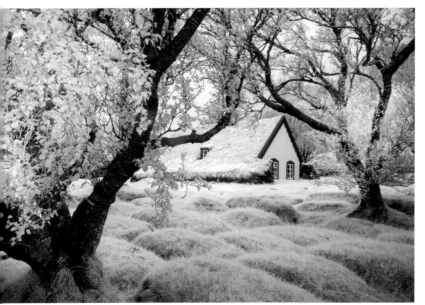

Hofskirkfa

bottom—This turf church, photographed in infrared, is named Hofskirkfa; it's the only church left with a grass rooftop.

Framing your subject can add impact in your image. After looking for frames within these trees, I found one.

Private Sanctuary

following page—Although there are churches throughout Iceland, many farms have their own sanctuaries and family plots. This large gateway frames the sanctuary perfectly. A 14mm lens made this perspective possible.

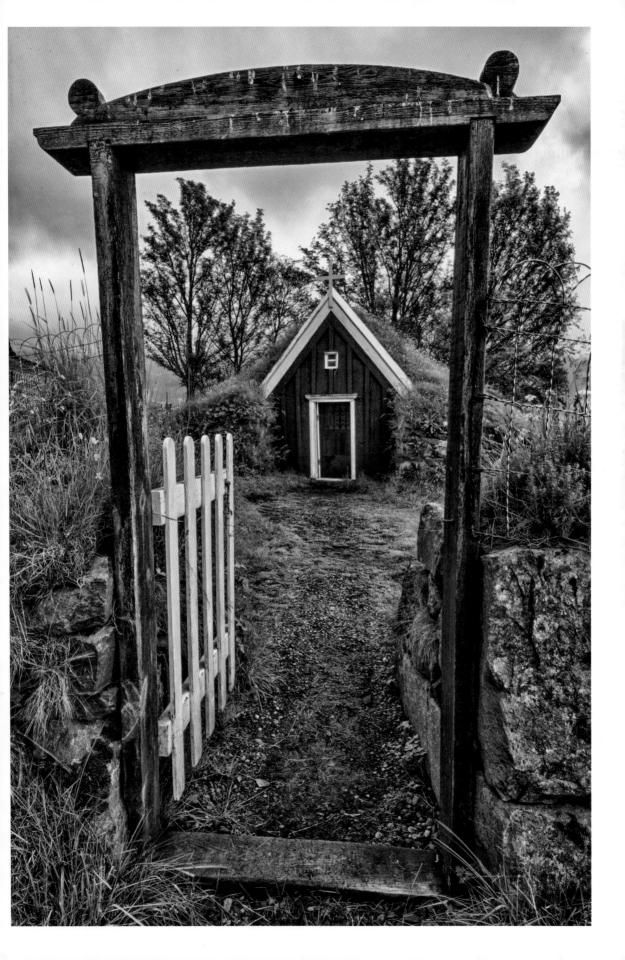

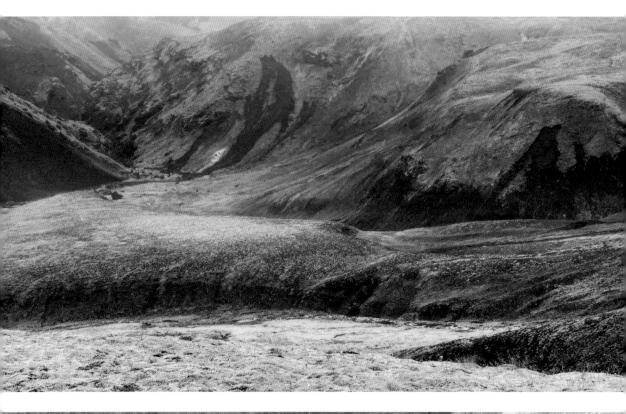

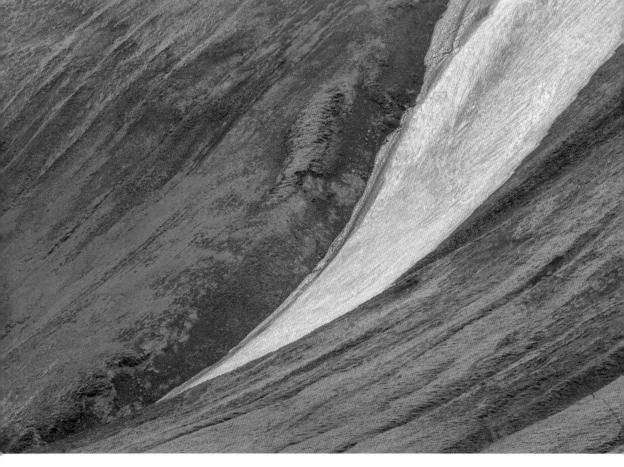

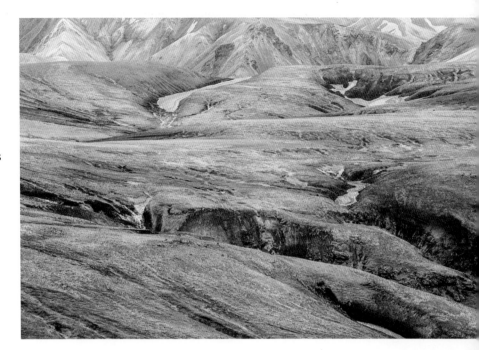

The Highlands

The pastel landscapes of Iceland. Fog and soft, overcast light bring out the softer side of Iceland.

All of the photographs on this and the previous page were made in the Icelandic highlands.

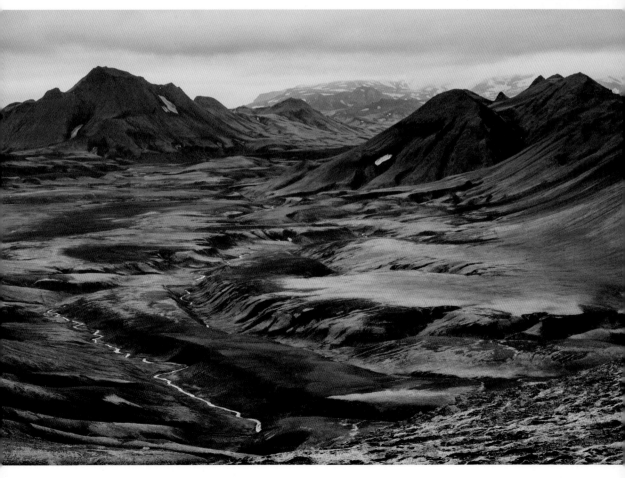

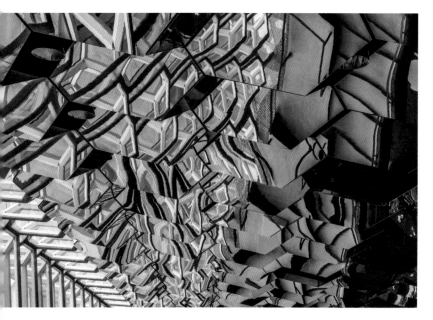

The Harpa

top—From the outside to the interior, the Harpa Fine Art Center is a wonderful photo venue. The light and color on and within the structure changes throughout the day into the blue hour. This image was made on the third floor, close to the multiple sections of angled glass in the ceiling.

Hallgrínskirkja

bottom—The multiple colored buildings were photographed from the steeple of Hallgrínskirkja, Reykjavík's most prominent church.

 following page—The interior of Hallgrínskirkja is a great subject, as the repeating patterns and light shading change throughout the day.

 At the bottom of the frame is the top of a pipe organ. Since the church is always crowded, photographing upward is excellent for the patterns and light, and avoids the people at ground level.

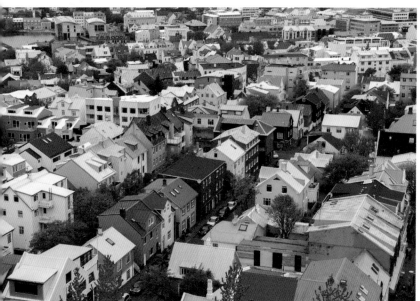

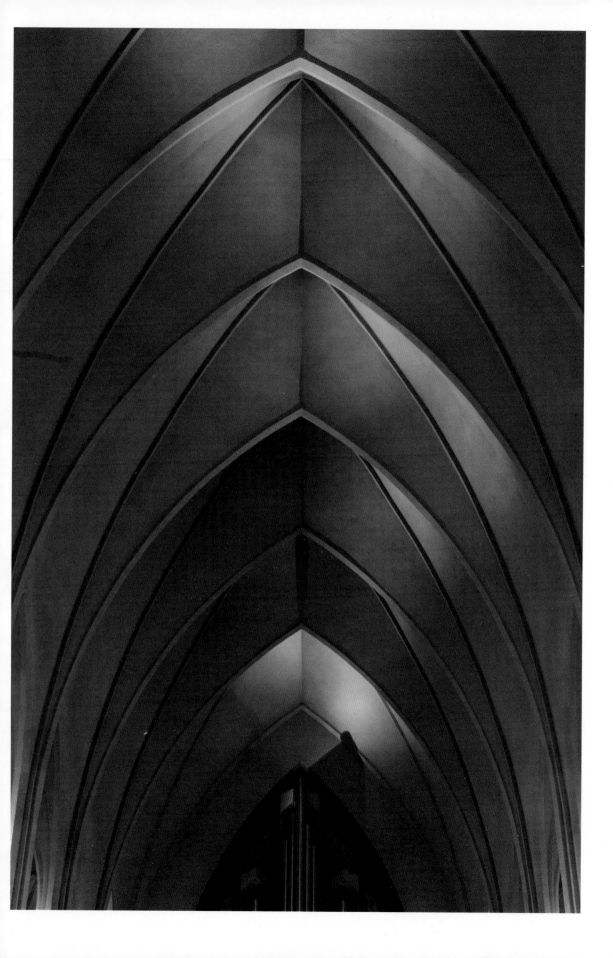

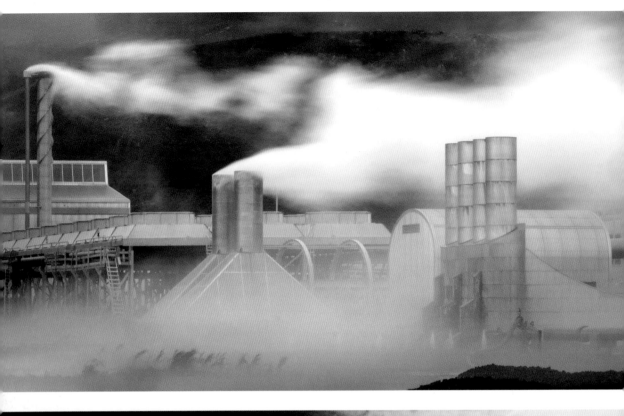

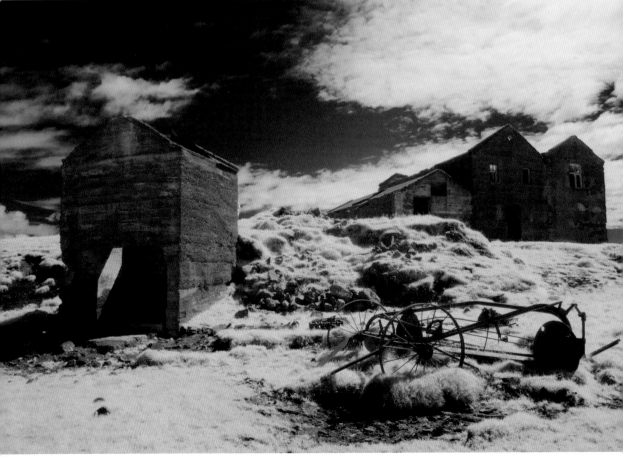

Svartsengi Power Station

previous page, top—This image was made during a 50mph sustained wind. I had to use a tripod and press it against the side of the bus to help ensure there would be no movement. I wanted depth in the scene, so my aperture was at f/14. In order to get a fast shutter speed, I raised the ISO to 800. Many images came out soft during the process; however, as I raised the shutter speed, the percentage of sharp images increased.

Abandoned Farm

previous page, bottom—Iceland is outstanding for infrared photography. In infrared, this scene takes on a surreal, dystopian quality.

Reykjavík

top—Room with a view. There are always great images to be made from our hotel room. We always request the highest floor available.

Iceland Interior

bottom—The hills are very green in the summer into early fall. Often mistaken for snow, greens are displayed as white in infrared.

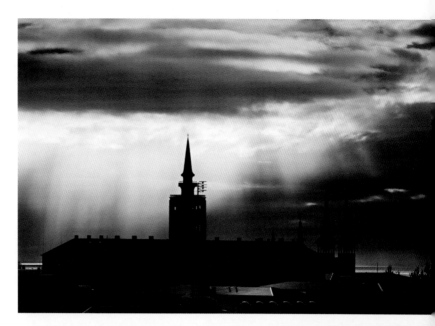

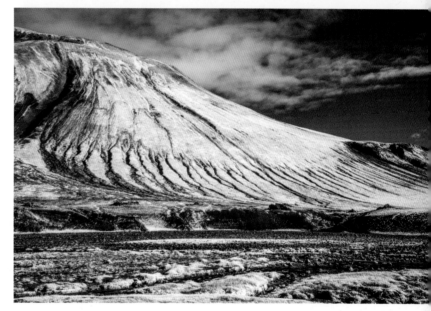

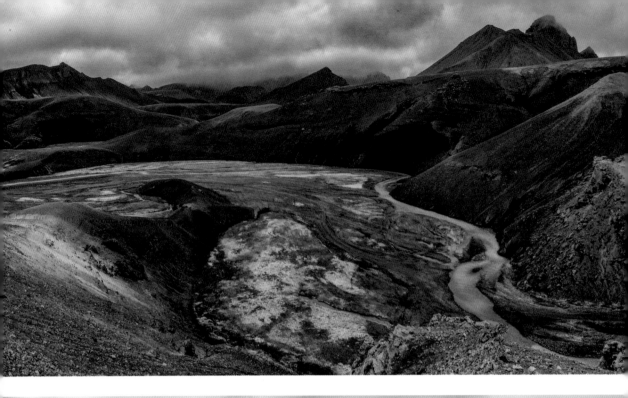

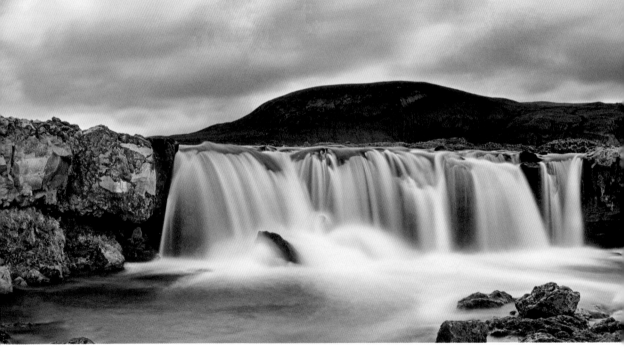

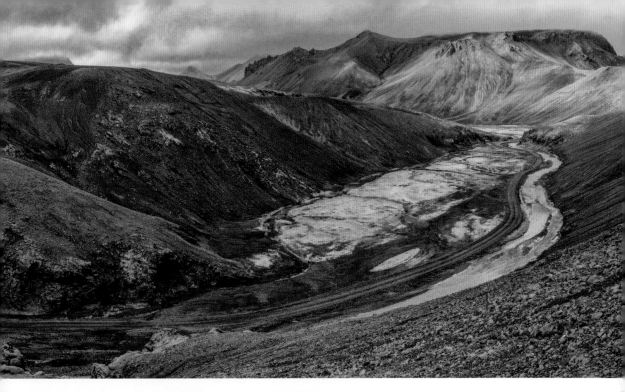

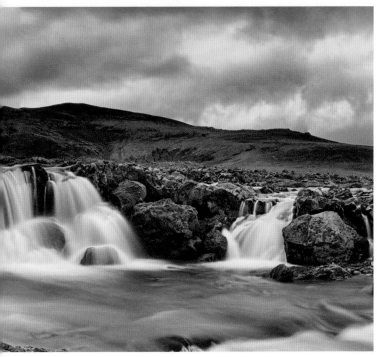

On the Road to Mývatn

top—This is a nine-image stitched panoramic, made on our way through the mountains en route to Mývatn. For precise rendering, I used a special panoramic device.

Iceland Interior

bottom—Image made during our 26-hour trip through the Iceland interior, where the land is devoid of trees. This nine-image stitched panoramic is stark and well represents what the scene felt like.

Outside of Rif

top left—Placing the farm low in the frame with the mountain quickly ascending into the background produced an image with dramatic scale. In general, a low-horizon composition will pull the viewer into the frame.

South Coast, Outside of Vik

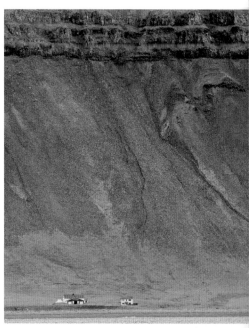

top right—A solitary barn in the vast Iceland landscape. One will encounter random lone subjects on any given drive in Iceland.

On the Road

bottom—As we were leaving Reykjavík and heading to Snæfellsness National Park for some post-workshop personal photography, we spotted this flowing cloud framing the red farm. Luckily, the cloud remained as we set up and shot multiple images, which were combined to create a panorama. This image includes red, green, and blue for maximum color impact.

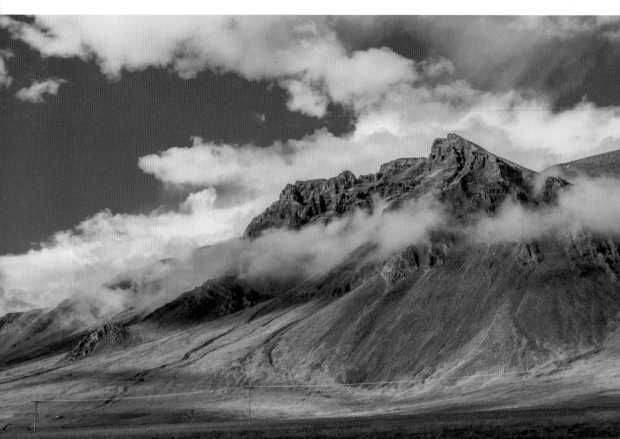

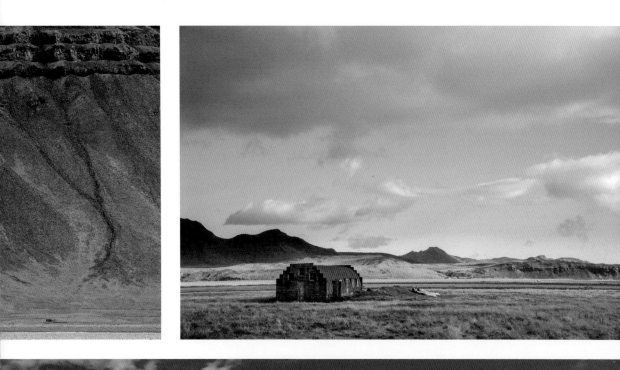

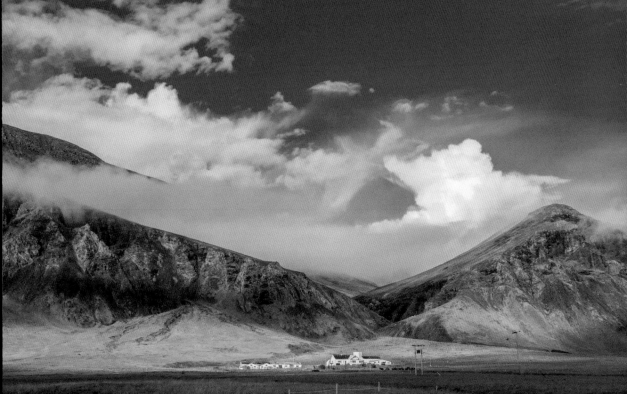

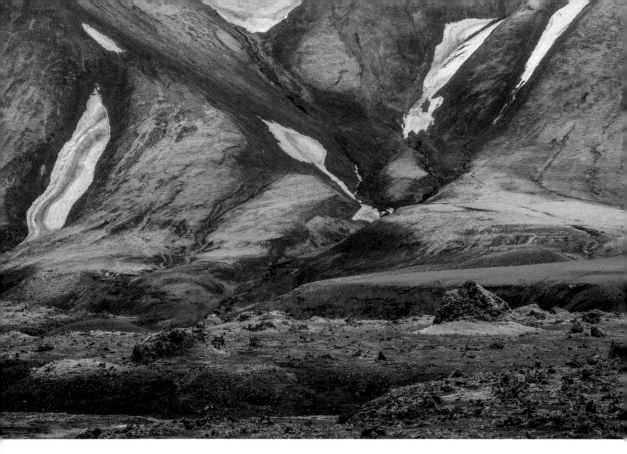

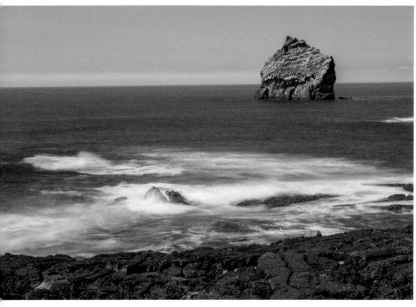

Iceland Scenics

top—Iceland interior: summer snow patches among the lime greens and foreground lava field.

bottom—Reykjanes, located on the lower east coast of Iceland.

following page, top—Thermal area. Be careful and do what the signs say. The dirt is soft around the holes and very dangerous. These areas are roped off.

following page, bottom—Daybreak in the Icelandic highlands.

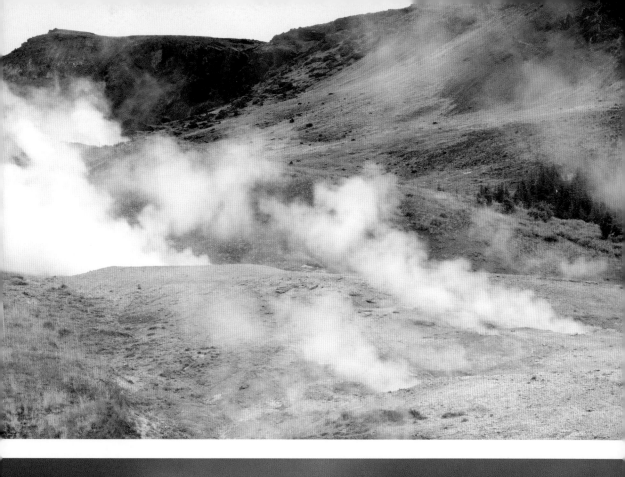

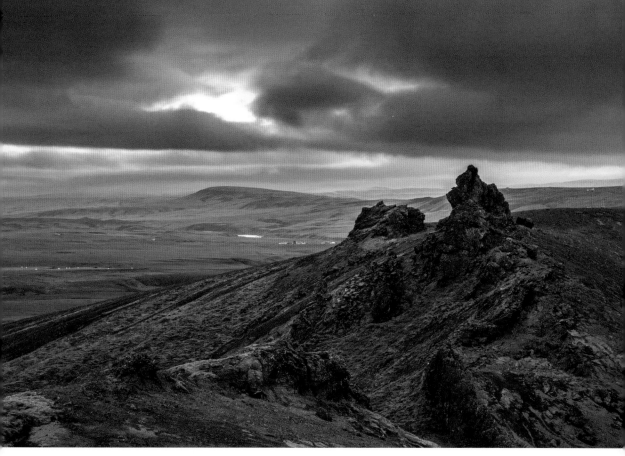

Four Images of Glacial Lagoons

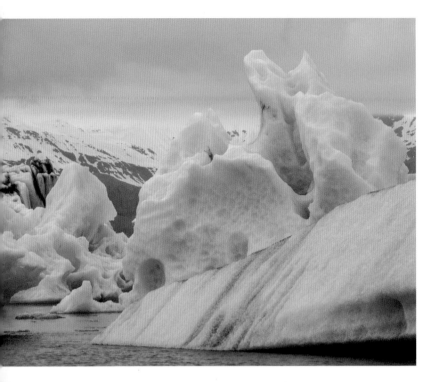

top—Jökulsárlón. Soft, overcast lighting is perfect for bringing out the subtle turquoise color of the ice.

bottom—Vatnajokull. The first touch of morning light is visible on Jökulsárlón in the back-right part of the frame.

following page, top—Jökulsárlón. A low camera angle allowed me to include the mirror reflection. Soft, overcast light evenly illuminated the scene.

following page, bottom—Vatnajokull. The soft first light seen in the previous image spread onto this lagoon.

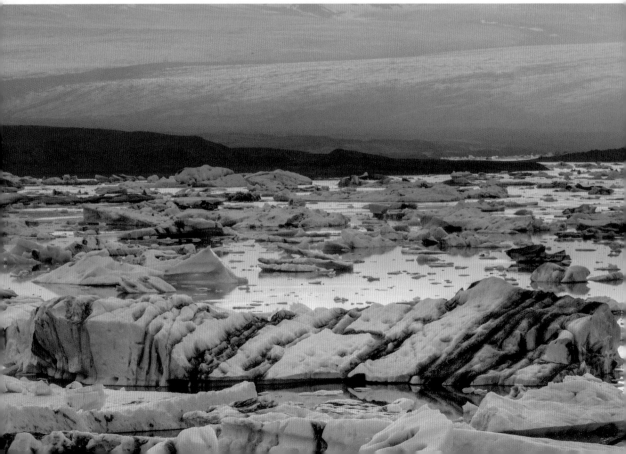

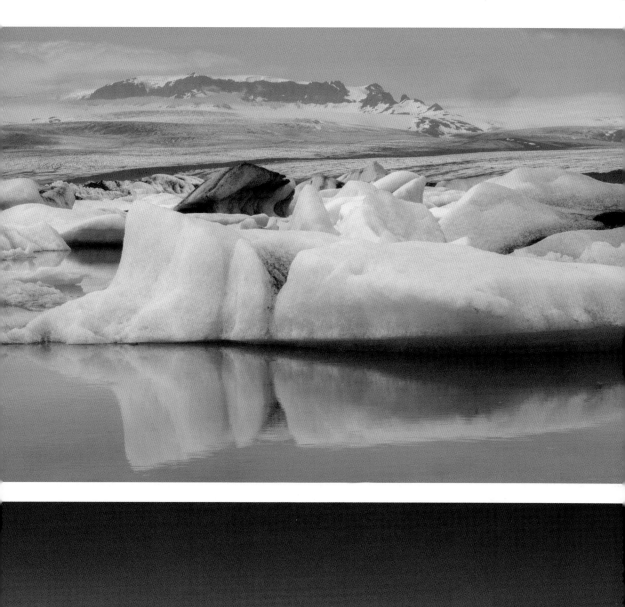
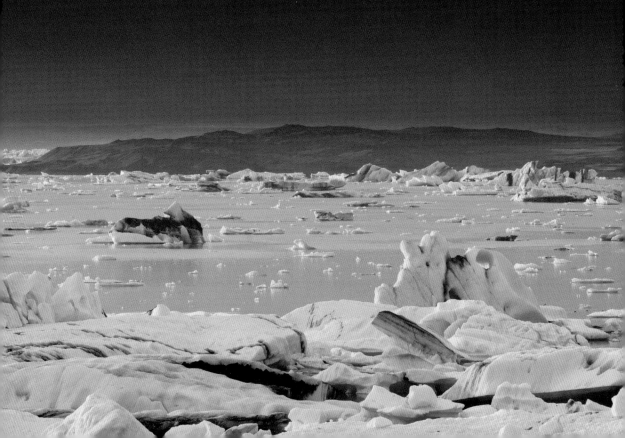

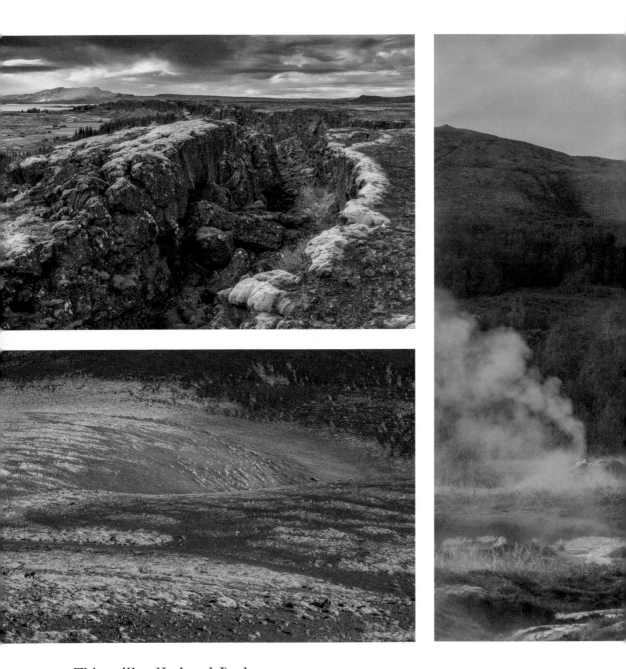

Thingviller National Park

top—Crack in the earth. The lichen-lined gorge separates the North American continent from the European continent.

Snæffellsnes National Park

bottom—The summer colors in northwest Iceland are amazing. This image was made using a telephoto lens to compress the layers of colors.

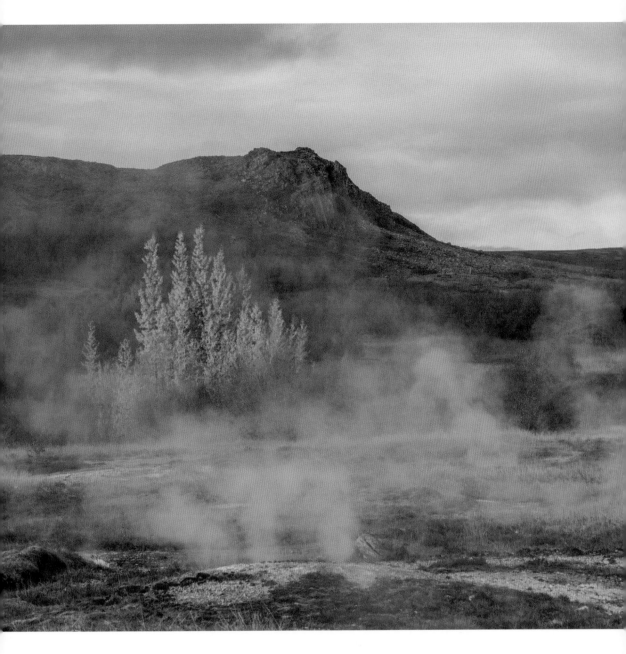

Strokkur

above—At Iceland's version of Old Faithful, Strokkur, the thermal springs create a fog. In this image, it enhanced the "mood" of the sunlit fall trees.

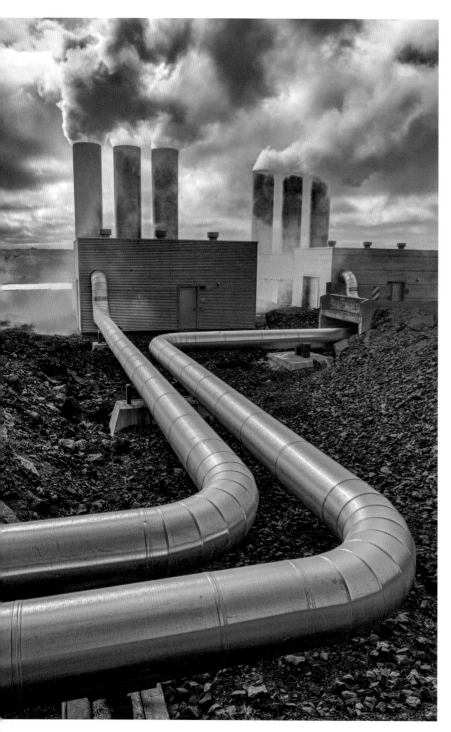

Svartsengi Power Station

left—This otherworldly scene and the stark graphics, leading lines, and repeating triple smoke stacks (distinctly separated) created a somewhat complicated composition that is easily viewable without distractions.

Gullfoss

following page—This image was made from a platform next to the falls. I used a 30-second exposure (with a 10-stop neutral density filter on the lens) to soften the water.

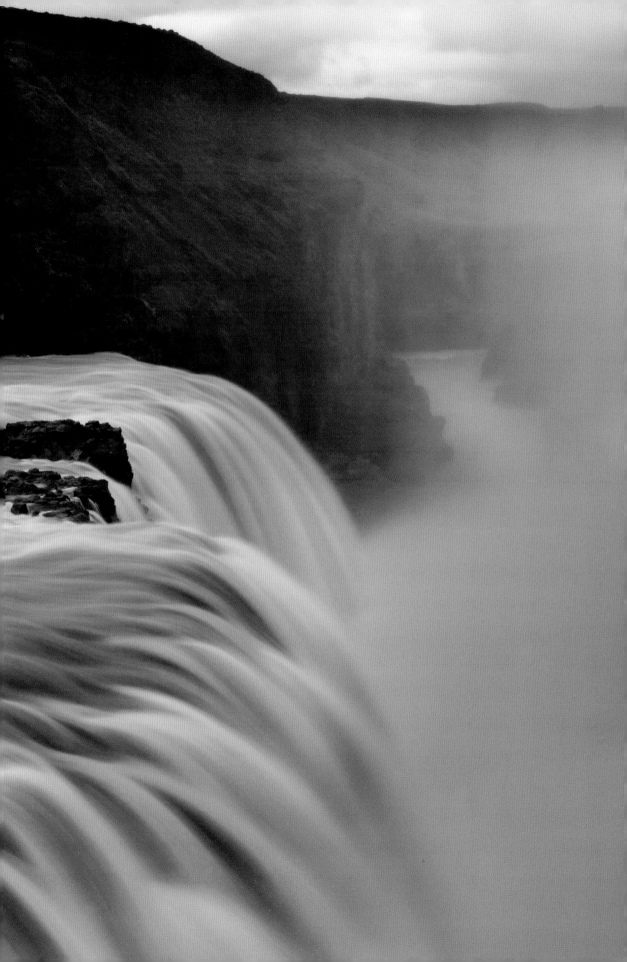

Three of Iceland's Great Waterfalls

top—Gullfoss, Golden Waterfall. This image was made from the fenced-in walkway on the way to the platform.

bottom—Dettifoss in infrared. To capture this image, I used a Nikon D800 converted to 720nm infrared, also known as standard infrared. Infrared has two unique properties: it increases cloud detail and creates a natural glow on highlights. Both properties illustrated in this photograph.

Aside from being one of the most powerful waterfalls in Iceland (passing 3.5 million U.S. gallons of water per minute), Dettifloss figures prominently in the opening sequence of the movie *Prometheus*.

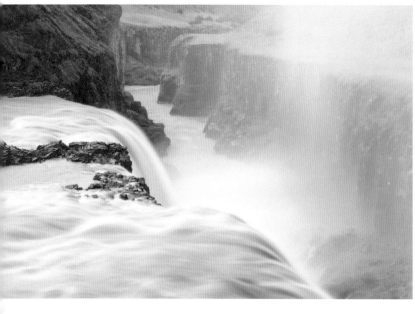

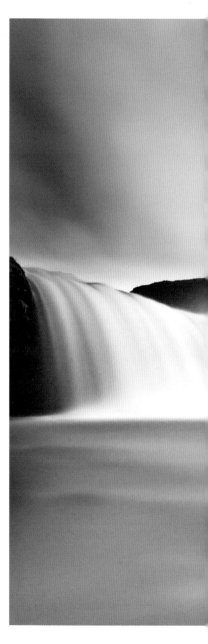

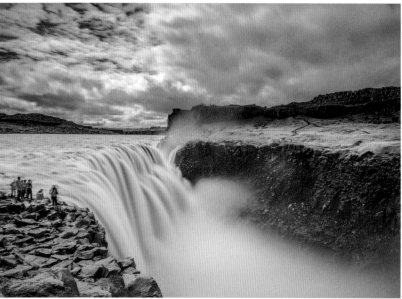

below—Godafoss, Falls of the Gods. I'd been hoping for years to get down at water level—and I finally did. The path is a bit challenging, as it requires one to walk on volcanic, sharp-edged rocks. Once I got to the desired spot, I made a 4-minute exposure, which recorded the flowing clouds over the falls and smoothed the waterfalls and foreground water. It's good practice, when possible, to include a "hard subject" in a long-exposure waterfall image. Here, the foreground rock serves as a visual anchor.

Be sure to bring a pair of kneepads when traveling to Iceland. Kneeling on sharp-edged lava rocks can be uncomfortable.

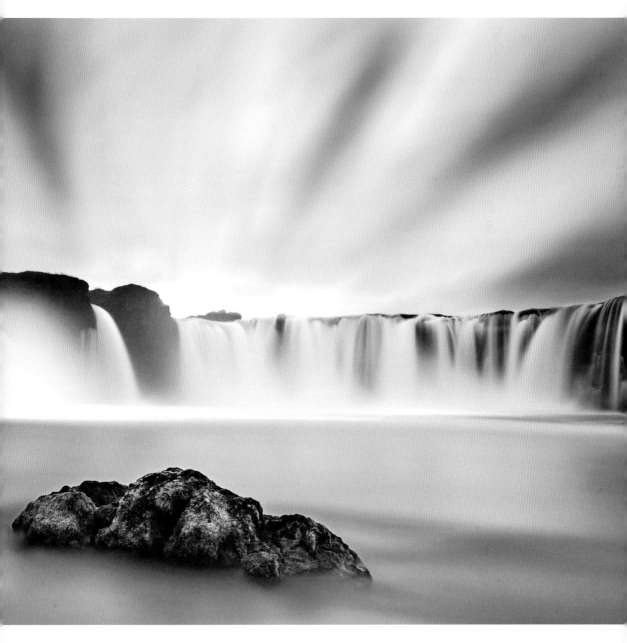

Central Iceland Highlands

below—Curvy roads are perennial story telling subjects, leading the eye into the scene. Photographing in infrared renders the light greens as white, while darkening the road, pulling the eye through the S-curve.

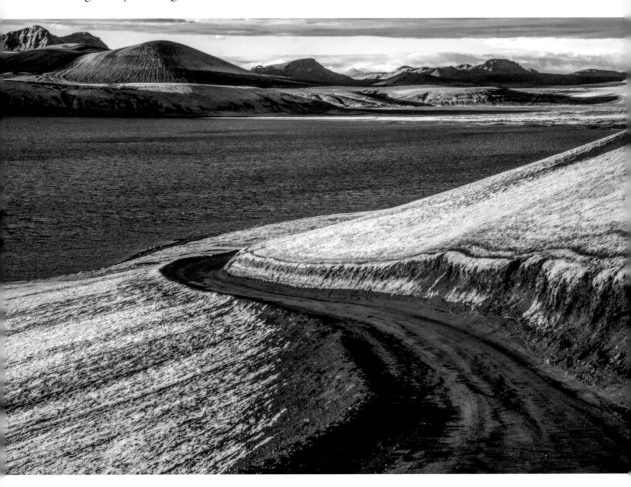

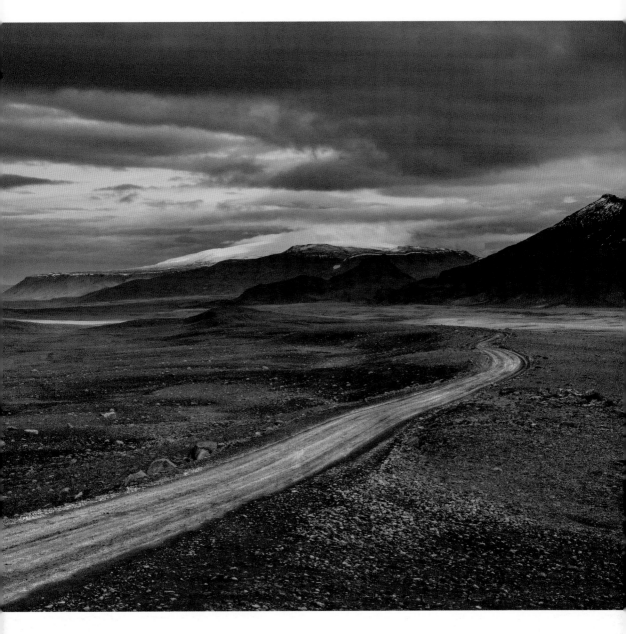

Thingvellir National Park

above—Long and winding country roads are throughout Iceland. This image, made at the edge of Thingvellir National Park, leads the eye to the distant hills.

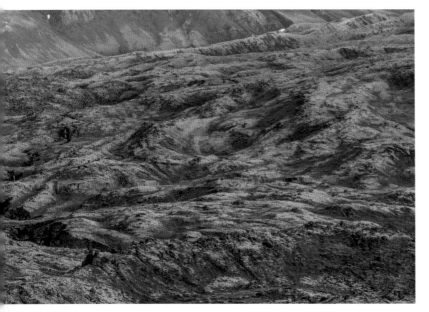

Westfjords

top—A large lichen-covered lava field in the Westfjords after a rain. The vibrant color of these fields depend on how wet or dry they are. They are most vibrant after or during a rain.

Note: All of the images on these two pages were made in overcast conditions, which is best for color quality and saturation.

bottom—During a volatile weather day, the clouds began to swiftly cross over the distant mountains, heading right toward us. A little farther down the road, we were fogged in for a while.

Mývatn

following page, top and bottom—The color attributable to mineral deposits.

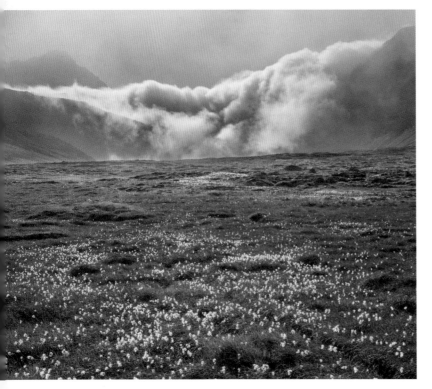

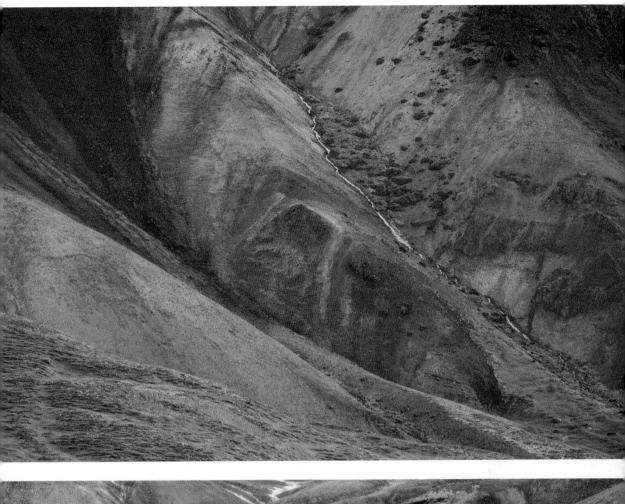
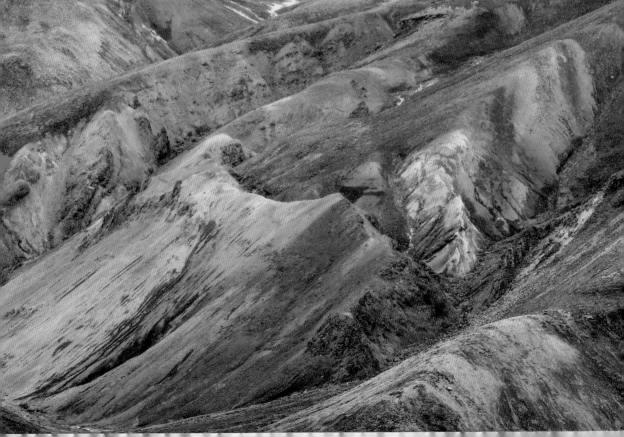

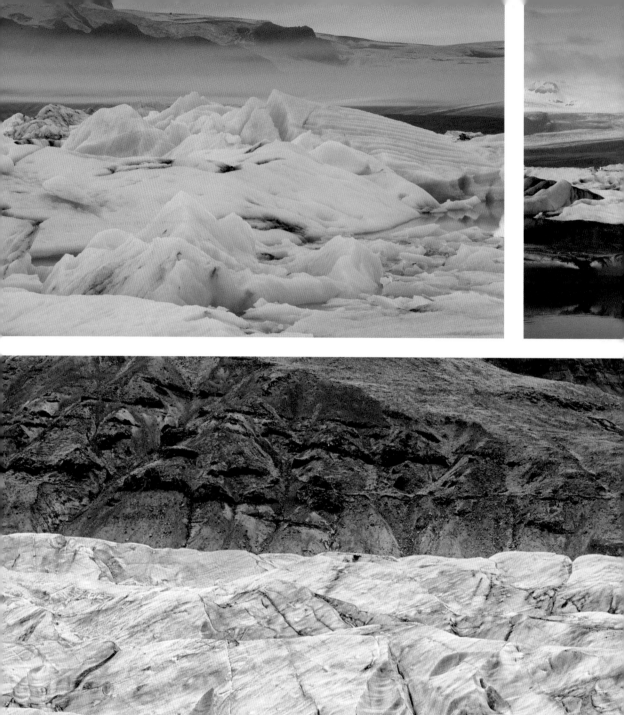

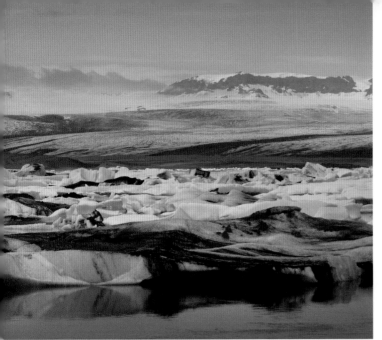

Jökulsárlón

top left—Jökulsárlón at dawn.

 top right—Glacial reflection at Jökulsárlón.

Svinafell Glacier

bottom—Glacial layers are exposed in July.

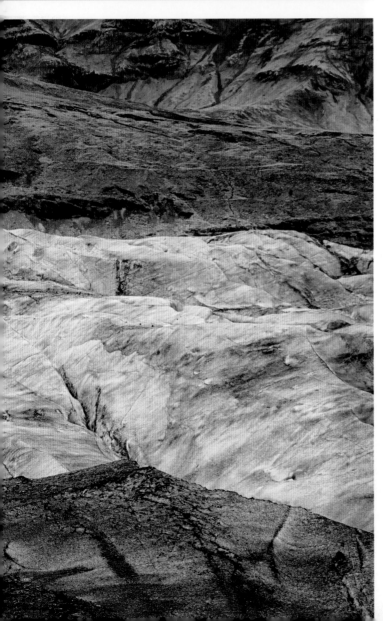

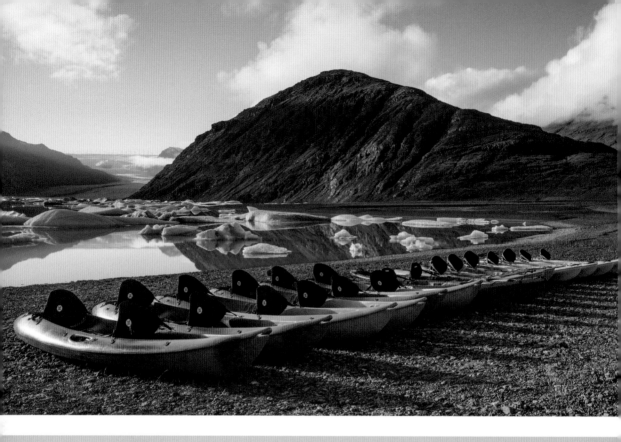

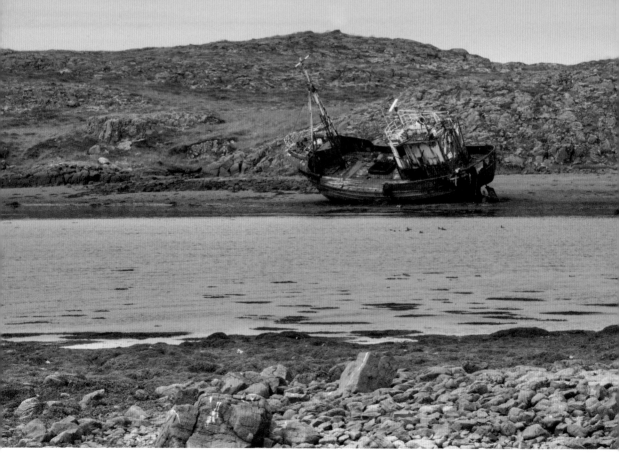

Fjallsárlón Lagoon

previous page, top—Kayaks lined up for glacial lake tours on the south coast.

Westfjords

previous page, bottom— Carrying a long lens is good for distant scenes like this one, located about a mile from our vehicle.

For this image, I used my 70–200mm lens and 1.4x teleconverter (340mm lens) for the highest magnification possible, then cropped in to the final composition.

Siglofjordur

top—Fisherman returning home in a very low tide in one of Iceland's most scenic towns.

Sunset

bottom—Northern Iceland.

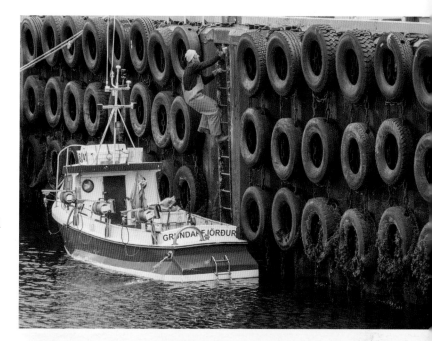

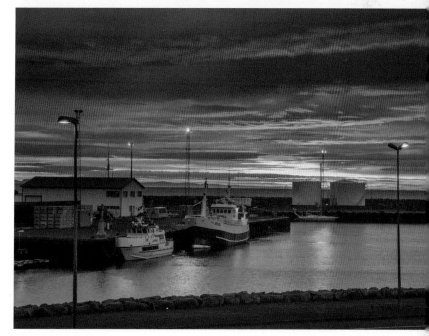

Heinaberg Glacier

top—Summer thaw on this south coast glacier and lagoon creates interesting line and textures.

Tern, Tern, Tern

bottom—Arctic terns are always flying around Jökulsárlón. There is a nesting area there.

I zoomed in to a small area and selected an aperture of f/8, which gave me a shutter speed of $^1/_{500}$; this was enough to freeze the birds. Next, I waited for birds to fill the frame.

It's a good idea to shoot many pictures, as one has no control over what the birds do or how they will be configured in the frame. This is one of only a few images that had the proper density and distribution of birds with good separation.

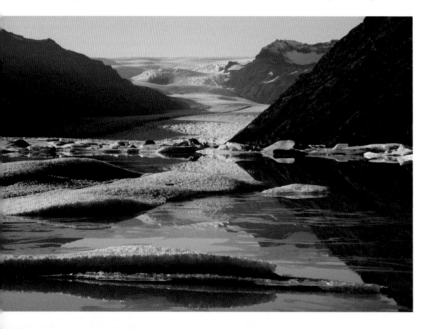

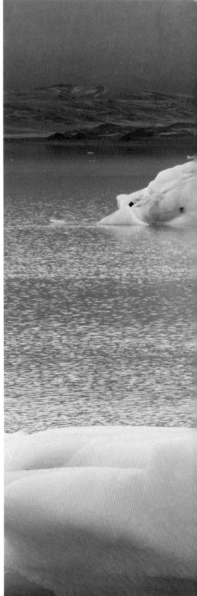

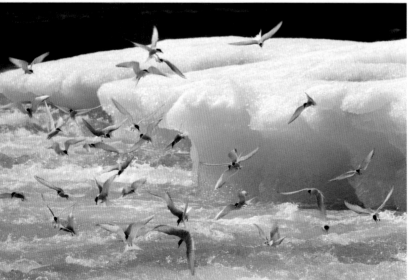

Jökulsárlón

below—Fog is unusual on Jökulsárlón. On this day, we were surprised by its presence. We photographed at this location for hours as the fog flowed in and out of the lagoon—with diffused sunlight.

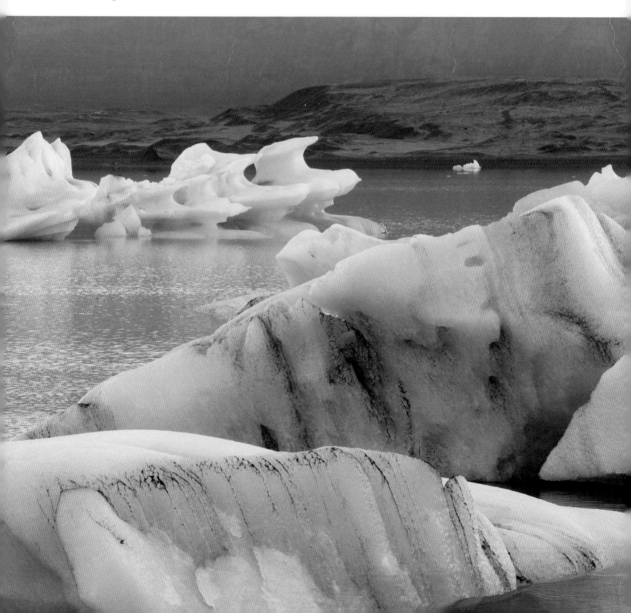

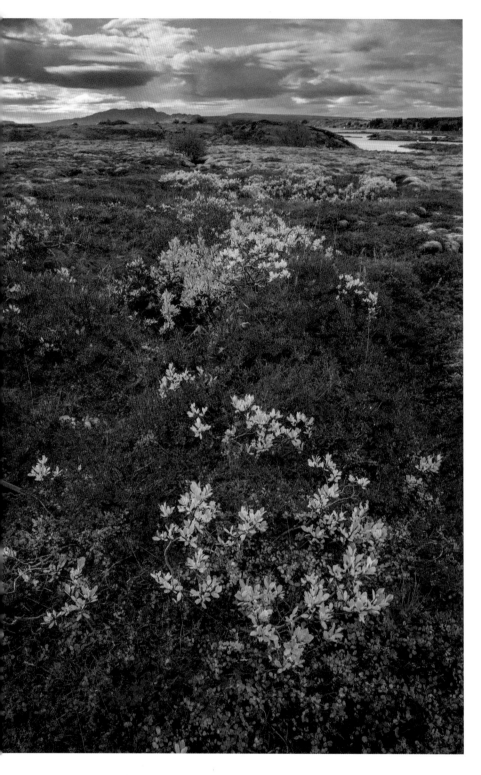

Thingvellir National Park

left—Magnificent fall color in Thingvellir National Park. This image, made in September, was made in a vertical format with a 24mm lens. The result is a wide depth of field and intense color.

The Northern Lights

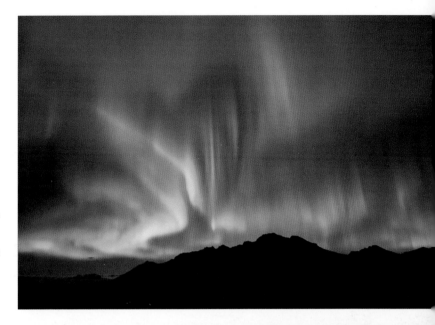

top—Iceland's auroras can be magnificent, but they are not viewable year-round. Complete darkness is required to see them. In late August/September, it starts to get dark. Because of cloud cover in the winter, auroras may be hidden. A clear night is best. There are aurora apps that will sound an alert when the right conditions are met.

Unless one is used to seeing auroras, they can have the appearance as clouds. When the light starts spiking or rolling, you are in the presence of the aurora borealis.

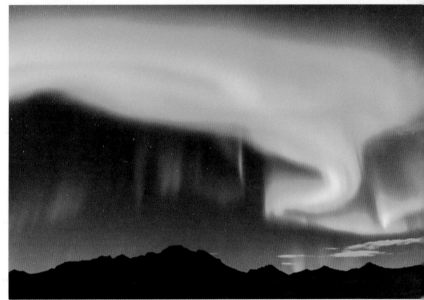

bottom—This particular display went on for over an hour. We just pointed our cameras at various areas of light and made images again and again.

During the day, we set our lenses' focus point on a distant subject and used gaffer's tape to keep the focusing ring from moving. Refocusing in the dark is not fun.

When photographing these displays, it's best to use your fastest wide-angle lens. I used my 14–24mm lens, set the ISO to 3200, and shot with the lens wide open at f/2.8. Your exposure should be in the 4–15 second range. Exposures are not as long as one may think; the auroras can be quite bright. On this night, most exposures were around 8 seconds. Bracketing at the beginning can help you get a working exposure. Be sure to bracket from there, too, as the length of the exposure will dramatically change the look of the light flow.

INDEX

AmherstMedia.com